BEGINNING MANGA

*An interactive guide to learning
the art of **manga illustration***

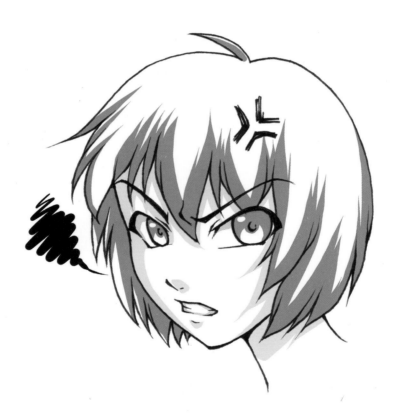

Walter Foster

Brimming with creative inspiration, how-to projects, and useful
information to enrich your everyday life, Quarto Knows is a favorite
destination for those pursuing their interests and passions. Visit our
site and dig deeper with our books into your area of interest:
Quarto Creates, Quarto Cooks, Quarto Homes, Quarto Lives,
Quarto Drives, Quarto Explores, Quarto Gifts, or Quarto Kids.

First Published in 2016 by Walter Foster Publishing, an imprint of The Quarto Group.
6 Orchard Road, Suite 100, Lake Forest, CA 92630, USA.
T (949) 380-7510 **F** (949) 380-7575 **www.QuartoKnows.com**

Walter Foster Publishing titles are also available at discount for retail, wholesale,
promotional, and bulk purchase. For details, contact the Special Sales Manager by
email at specialsales@quarto.com or by mail at The Quarto Group, Attn: Special Sales
Manager, 401 Second Avenue North, Suite 310, Minneapolis, MN 55401 USA.

ISBN: 978-1-63322-075-1

Layout design: Ian Thomas Miller

Printed in China
10 9 8 7 6

TABLE OF CONTENTS

INTRODUCTION

So, you want to draw manga? Good for you! All it takes to get started is feeling inspired by this fun, exciting art form and having the courage to give it a try. There are a few things to consider before you begin. For example, a good manga artist knows how to draw anatomically correct, stylized figures. When you look at a manga picture you like, don't just copy it; analyze it! Which inking technique was used? Why did the artist include a specific feature? How long is a certain line in relation to the other elements?

That brings us to what this book is about. Two of the very first things you will learn are key shapes and ratios so you can draw manga from scratch. With plenty of practice using guided exercises, you will not only draw people and learn the fundamentals of backgrounds, but also create complete pictures of characters in appropriate settings. Finally, you will learn to create a story by writing effectively and planning your page layouts so readers can easily enjoy them.

What's great about manga is that it truly is for everyone. You can make it about anything you like. There are tons of manga drawing styles that range from minimalistic and abstract to hyper-realistic. Once you master the basics, you can create a style that's truly your own.

I hope this is just the beginning of your manga journey. Keep drawing, and never give up!

Manga is a generic term that describes Japanese comic books and graphic novels.

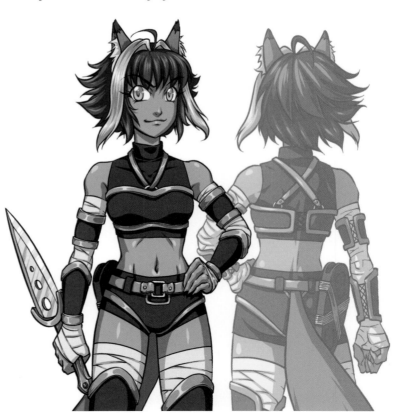

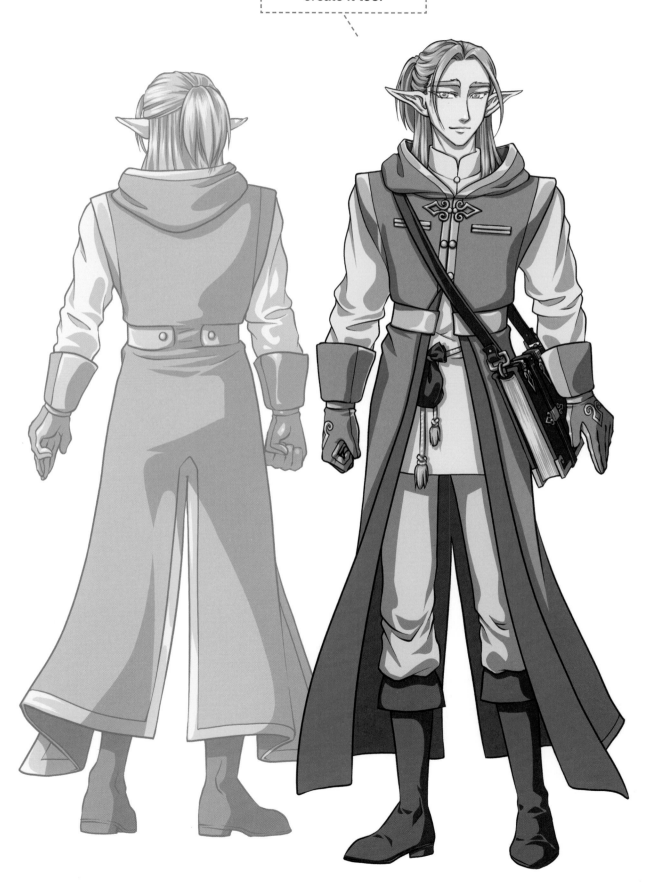

Today, manga is read all over the world, and artists, or *mangaka*, outside of Japan create it too.

TOOLS & MATERIALS

You probably already have a lot of the tools to draw manga. If you buy professional items, invest in tools that will last. Less expensive options work well too. The following is just a quick list of some of the tools you might want to use. More details on how to use each item are included throughout the book.

PENCILS & SKETCHING

Pencils: These are the most common and versatile tools. HB, B, and 2B pencils are easy to use and can add contrast. A mechanical pencil is great for sketching but not for shading, because its point stays thin.

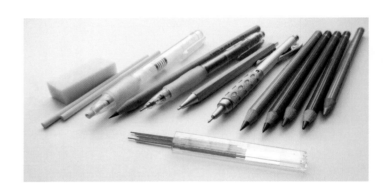

Non-photo blue/non-repro blue pencil lead: This particular shade of blue doesn't show up when photocopied, so it works well for sketches, which can then be inked over in your final drawings.

BRUSHES, PENS & INKS

Manga is predominantly a black-and-white medium. Even when the art is colored in, it usually features crisp, black outlines, so most manga artists prefer to use pure black ink.

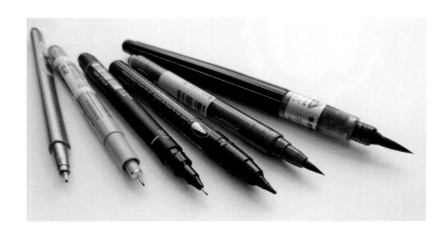

Fineliners: These come in different widths and are easy to use, making them the ideal drawing tool for a beginning manga artist.

Brush pens: Placing more pressure on the brush will thicken your lines, while light pressure produces very fine details.

Dip pens: Dip pens were, and still are, the traditional tool for a professional illustrator. Metal nibs are perfect for manga artwork; by changing pressure, you can go from super-fine, feathery lines to thick, bold strokes.

Brushes: These produce thicker lines than nibs as well as drybrushed textures for shading.

ADDING COLOR

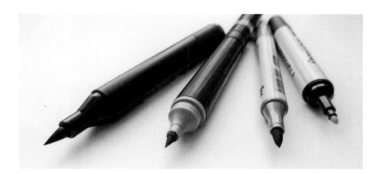

Colored pencils: When used in layers, these can create shading. Sharpen them for outlines and strong details. A chiseled tip is great for shading.

Markers: The most popular tool for coloring manga remains the marker. Keeping your strokes wet as you go over them again makes them look smooth and blended, or let the strokes dry first before adding more to create a distinct darker layer without blending.

DIGITAL TOOLS

You can also digitally sketch, ink, shade, and color your manga drawings. This book focuses on more traditional techniques, such as drawing and inking by hand; however, you might want to look online for digital art suggestions. (See page 20 to learn how to add color digitally.)

DRAWING BASICS

Manga might look very simple, but a good manga artist definitely knows how to draw.

GETTING STARTED WITH SHAPES

Look at the items around you, and try to simplify them into basic shapes, such as circles and polygons. For example, a bicycle is made of two circles, with a triangle connecting them. To show more volume and depth, switch to spheres. A tree is really a thin cylinder with a large sphere on top.

When you draw characters' faces, do it the same way. Don't get too hung up on the exact shape of the nose, chin, and other small details. Imagine you are trying to sculpt a face out of clay. Which shapes would you start with?

A character's head is mostly round with a protruding jaw at the bottom, forming an egg shape.

Imagine you are sculpting a face out of clay. Which shape would you start with?

RECOGNIZING RATIOS

Faces come in many different shapes and sizes. Use ratios to recognize what they all have in common. Is a certain feature always located about halfway between two other features? So many things rely on the same ratios, which you'll discover when we go over drawing faces starting on page 22.

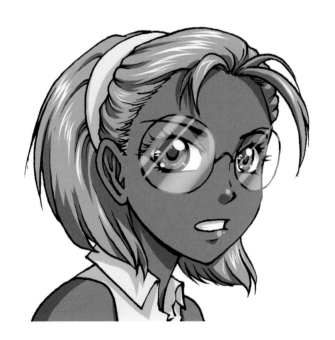
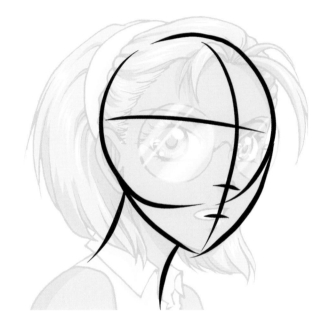

Drawing a line across the eyebrows demonstrates that the tip of the nose is located roughly halfway between the eyebrows and the chin.

EXPANDING TO LARGER SUBJECTS

To draw a character's entire body, concentrate on the main features, such as muscle groups and joints. Use ovals to help visualize muscles and circles for rounded joints like shoulders and knees.

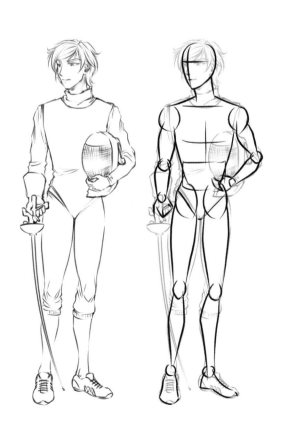

INKING BASICS

Inking is an incredibly important skill for a manga artist to learn. Manga is a mostly black-and-white medium, so the ink is ultimately what your viewers will see, meaning you have to convey lots of information about texture, volume, and depth in your inked lines.

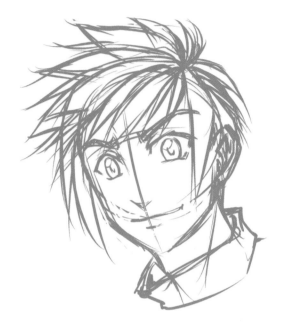

Take a look at this sketch of a young man.

Here the sketched lines are traced over, without changing the line weight or thickness.

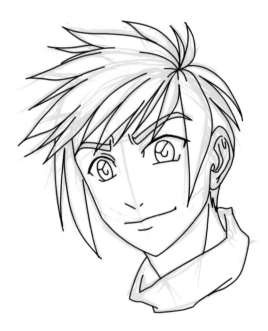

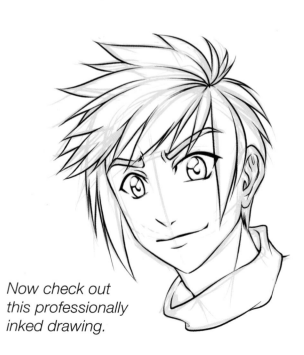

Now check out this professionally inked drawing.

It's pretty clear which piece is most skillfully inked, but ask yourself: What makes it so much better?

TAPERED ENDS

Make your lines look decisive, smooth and, above all, tapered. An illustration will look flat and lifeless if you use the same line width throughout, so try to end your lines by lifting or flicking up your pen to get a super-thin finish. Wobbly, feathery lines can look slow and hesitant. Inking too slowly and pressing too hard causes ink to pool, blunting the ends of your lines.

Tapering is particularly effective on hair, blades of grass, and anything else that requires a sharp end.

DISTANCE

When something is closer to the viewer, it should be inked with thicker lines. Thinner lines create a delicate appearance, which suits a distant object. Drawing with thinner lines gives an almost faded appearance and is a simple way to add depth to a drawing.

Compare these two drawings. In the second image, notice how the circle in front features the thickest lines, with a slight thinning at the top-left corner. It casts a small shadow on the rectangle immediately beneath it. The triangle is much farther away, so it doesn't include a shadow. There are some gaps in the lines where it meets the rectangle, and it is inked with very thin lines.

SHADING & COLORING

Volume and depth really come into play when you start adding shadows and highlights. Whereas traditional manga sticks to black and white (or grays rendered in black-and-white dots and patterns), covers, promotional images, and standalone manga artwork are often colored. Here are some techniques to help you with shading.

SHADING

First, pick a light source. Next, ensure that any surface closest to and facing the light source is brightly highlighted. Surfaces far away and facing away are in shadow. An object in front of another one casts a shadow on the object behind it.

Start by looking at simple shapes. Then look at real faces and your favorite manga drawings to see how shading is handled on more complicated subjects.

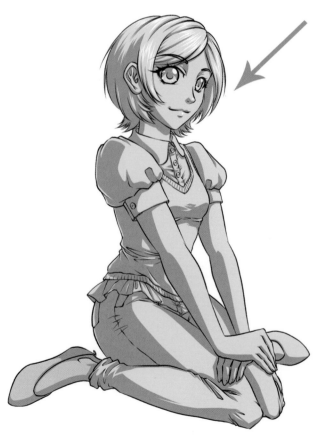

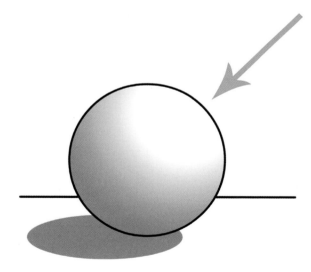

Here the light source comes from the top-right corner.

Look at this example of a young woman. The shading is kept simple with sharp shadows, midtones, and highlights on the bottom-left portion of her body. There are some white highlights at the top right, particularly on shiny surfaces like her hair and eyes.

COLORED PENCILS

Colored pencils are easily available and often the first art materials that children pick up, but there is a world of difference between filling in a coloring book and making a manga illustration really pop.

Here are some important considerations:

- You can use a cheap pack of colored pencils for most things, but buy good-quality pencils for pale tones like flesh.

- Don't outline in graphite pencil or black pen. Graphite lines will deaden your drawing, and black inked lines will contrast too much with the soft coloring. Use colored pencils in darker shades.

- Don't stick to one color or shade on a surface. Colored pencils can produce rich layers of tones and are very easy to control.

- Sharpen your pencils often. You want to sharpen a pencil to a point for fine, dark details, and then work it into a chisel and hold the pencil sideways with less pressure to fill in large areas.

- Be mindful of the directions of your lines, and try to be consistent. Stick to one direction in an entire image, or match the direction to the contours of the surface that you're coloring.

Here is the palette for the image on page 14.

COLORED PENCIL COLORATION

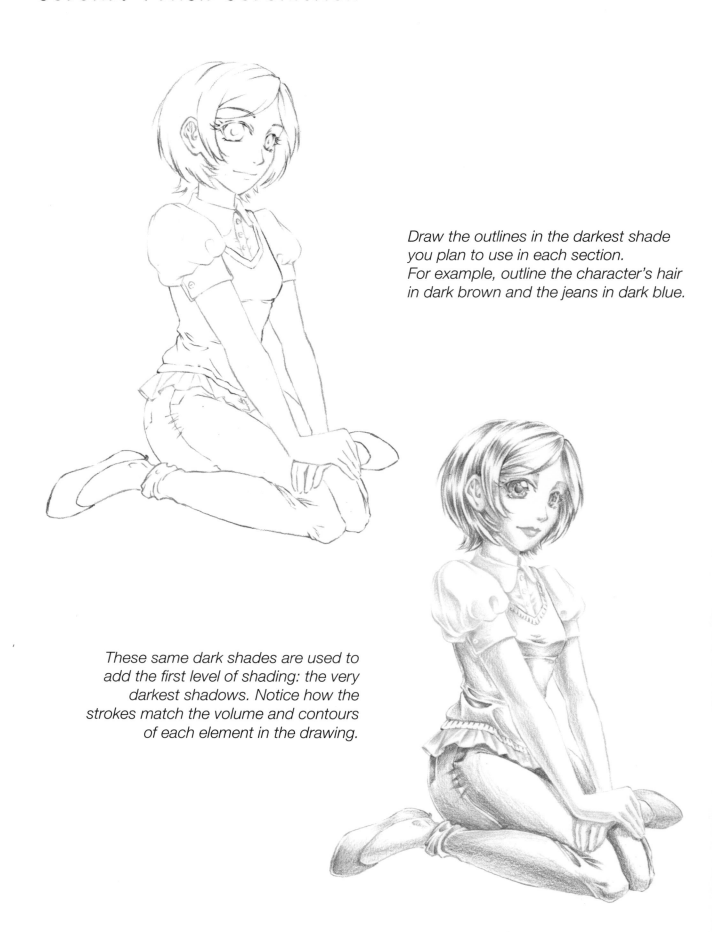

Draw the outlines in the darkest shade you plan to use in each section. For example, outline the character's hair in dark brown and the jeans in dark blue.

These same dark shades are used to add the first level of shading: the very darkest shadows. Notice how the strokes match the volume and contours of each element in the drawing.

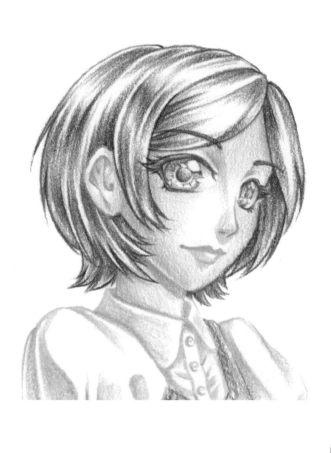

Add another layer of shadows, softly creating more depth and saturation.

Finally, layer the lightest shades on top for maximum color strength, and create highlights by blending into the white paper.

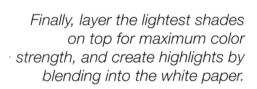

MARKERS

The manga artist's favorite traditional medium for adding color to illustrations, the marker, consists of a felt-tip pen, often with a brushlike tip. It's transparent, allowing you to add color on top of your outlines without obscuring them.

Here are a few things to remember:

- Color over marker-proof lines.

- Use smooth paper. Place something underneath the paper if the ink bleeds through.

- Overlap your strokes as you work. This allows the strokes to merge smoothly, creating a textureless blend.

- Work quickly if you want to blend gradients. Fill in the shadows, and then work over them in a lighter shade to create a seamless fade.

- Rather than completely filling in certain areas, concentrate on the shadows to enhance the contrast, and use the white of the paper to showcase highlights. Add opaque white ink highlights (only in small amounts).

Buy the exact colors of markers that you need. They don't need to be mixed, and their colors remain the same after drying. If you want to darken a certain color, let it dry, and layer on top.

MAKING A MARK WITH MARKERS

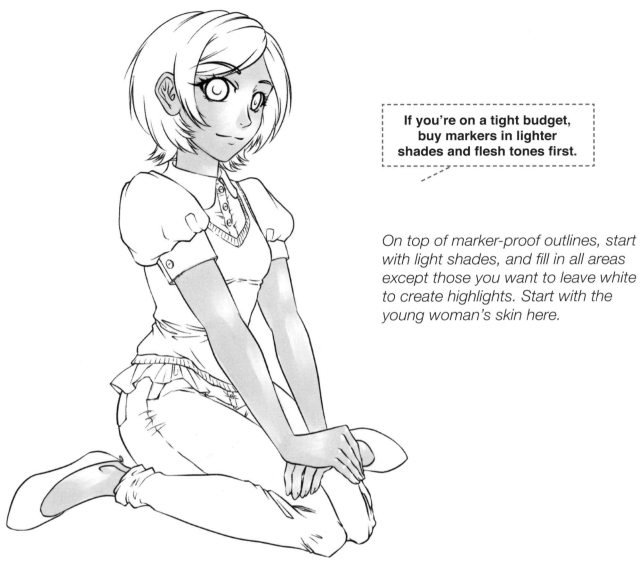

If you're on a tight budget, buy markers in lighter shades and flesh tones first.

On top of marker-proof outlines, start with light shades, and fill in all areas except those you want to leave white to create highlights. Start with the young woman's skin here.

Add darker shades on top to continue coloring her skin, and blend the dark and light colors.

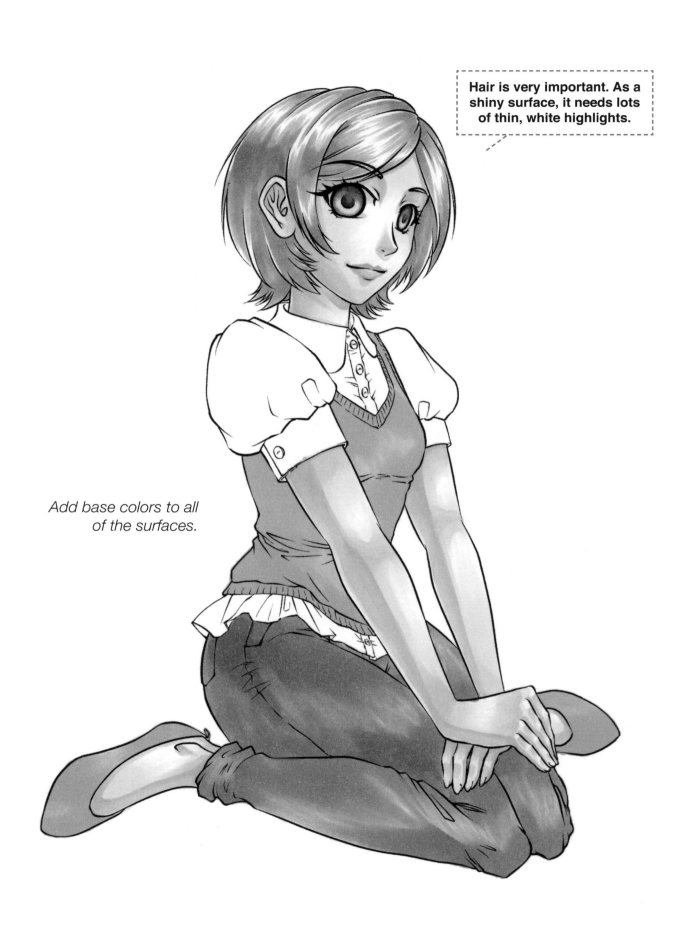

Hair is very important. As a shiny surface, it needs lots of thin, white highlights.

Add base colors to all of the surfaces.

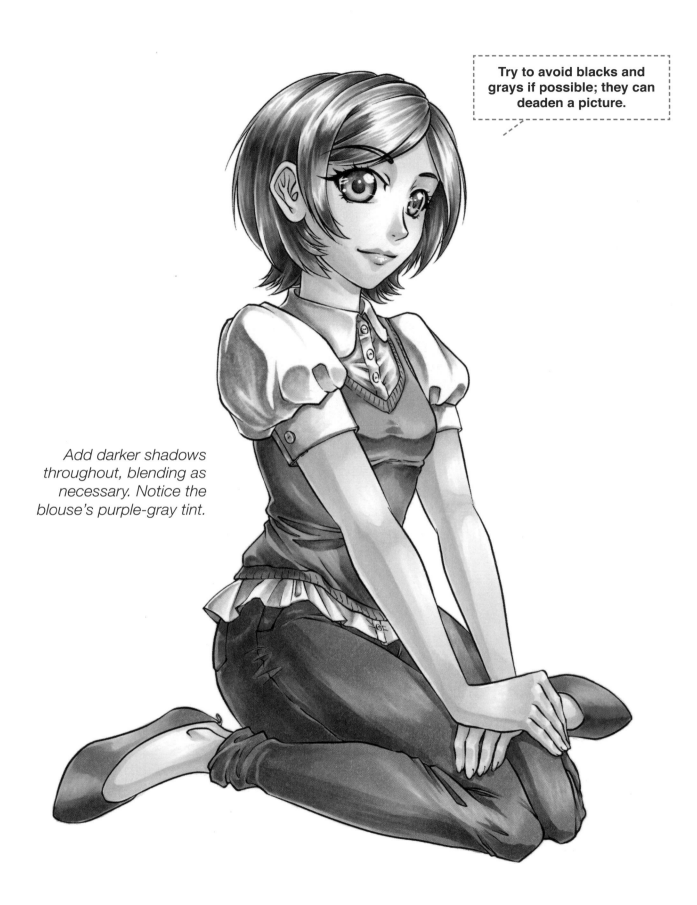

Try to avoid blacks and grays if possible; they can deaden a picture.

Add darker shadows throughout, blending as necessary. Notice the blouse's purple-gray tint.

DIGITAL COLORING

There are many styles of digital coloring, from the classic sharp shading and bright colors of anime cel art to soft, painted styles that emulate oil paintings. Let's take a look at cel-style shading. Once you learn the basics, you can apply the same techniques to other styles.

Here are the essentials for efficient digital coloring:

- Graphics tablet or tablet computer with a stylus.

- Painting- or image-editing software that lets you work in layers.

- Choose your colors wisely. Balance brights with neutrals and pastels, and keep your shadows colorful. Above all, go for high contrast; your shadows and highlights need to stand out from your midtones!

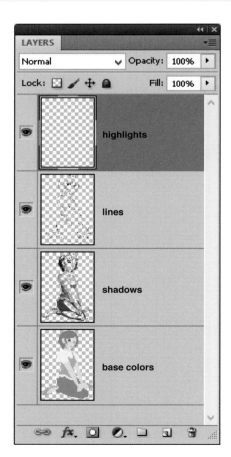

Use a few muted colors along with very bright, saturated ones. Notice that there isn't much black or gray.

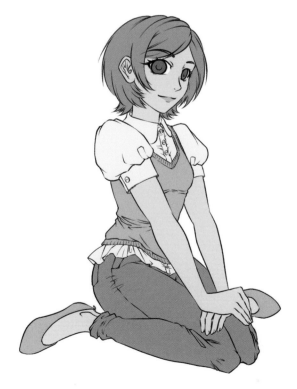

With digital coloring, start by creating lines on a clean layer. On a layer underneath, fill in all of the areas with midtones. This is called "flatting." Make sure to eliminate gaps between the filled-in colors and the lines.

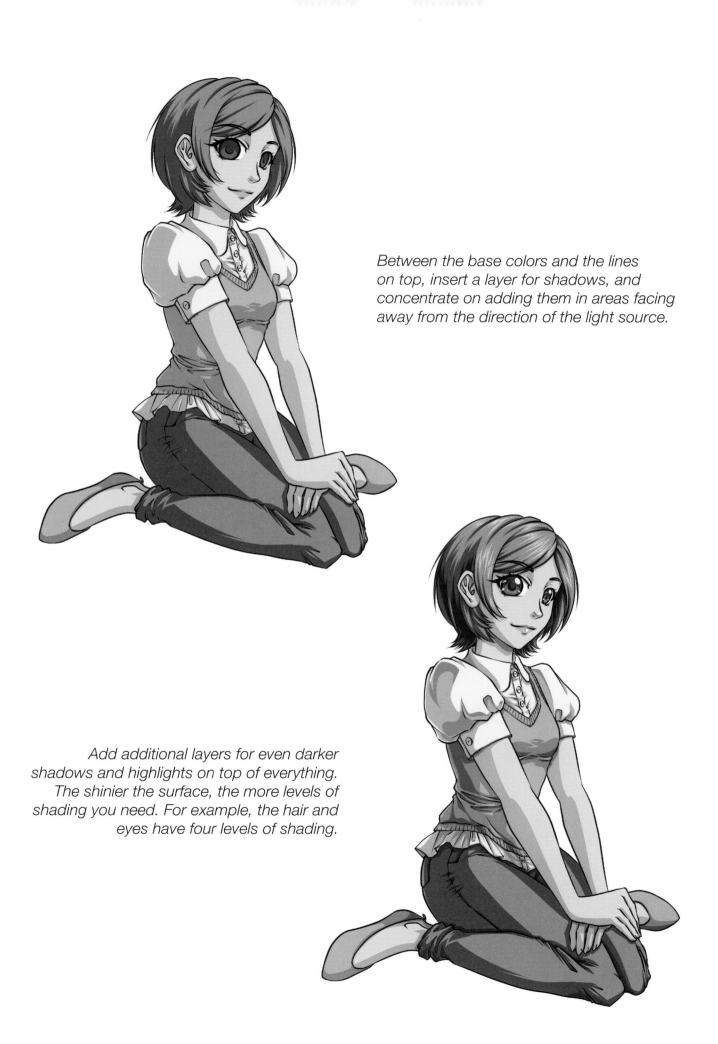

Between the base colors and the lines on top, insert a layer for shadows, and concentrate on adding them in areas facing away from the direction of the light source.

Add additional layers for even darker shadows and highlights on top of everything. The shinier the surface, the more levels of shading you need. For example, the hair and eyes have four levels of shading.

THE BASICS: DRAWING FACES & BODIES

A fully finished manga drawing might seem intimidating to an aspiring artist. Where do you start? How do you create an original drawing without copying the outlines of an existing one?

Even professional artists don't pull their drawings out of thin air. First they memorize some simple rules for anatomy and facial structure, and then they start by sketching basic guidelines and laying out poses before gradually adding details. Experienced artists just use fewer guidelines!

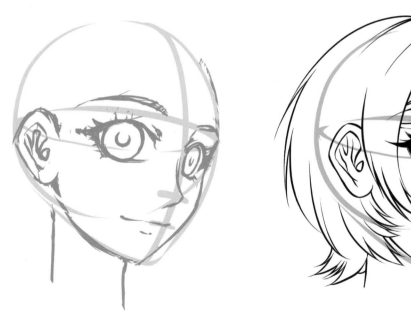
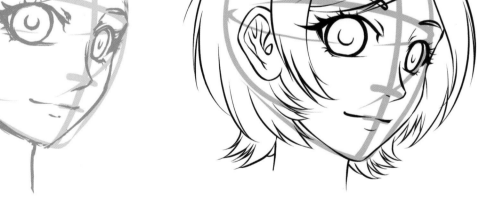

DRAWING FACES

Many manga artists begin by drawing an egg shape and laying some crosshairs to represent a character's head. Final details include shrinking and stretching facial features and shaping the hairstyle.

DRAWING BODIES

An artist usually can't draw a full body perfectly without first sketching the whole character. You don't want to start adding details and then realize you haven't left enough room for the feet! Start by drawing a stick figure, which you'll use to understand the lines and lengths of your character's body before fleshing out the figure. Then add clothing.

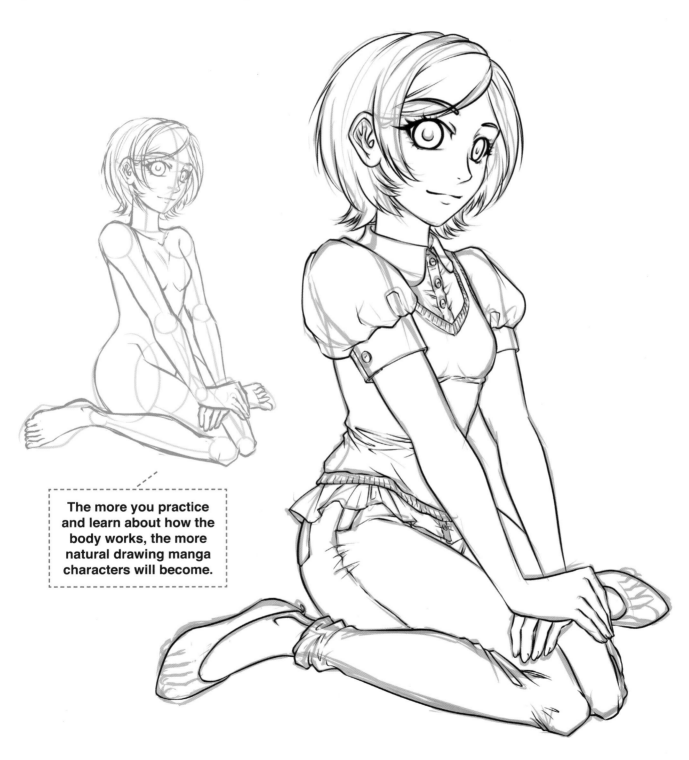

The more you practice and learn about how the body works, the more natural drawing manga characters will become.

DRAWING A FRONT VIEW OF A FACE

Let's start with a front view of a face. This will help you draw the simple shapes that make up the face and correctly position your characters' facial features.

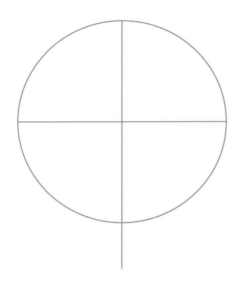

Start by drawing a circle, and then divide the circle in half for the brow bone. Draw a centerline down the middle.

Join the sides of the circle to the bottom of the centerline to make an egg shape. The eyes sit below the brow bone and are positioned almost exactly halfway down the head. Add another guideline.

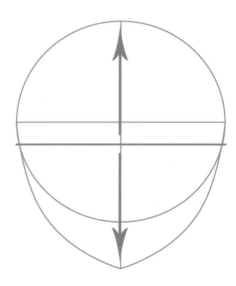

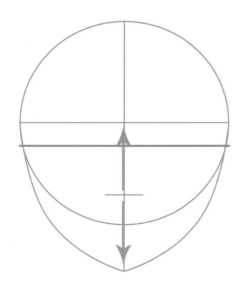

The tip of the nose is halfway between the brow bone and the chin. Add another guideline.

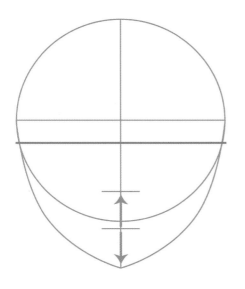

The mouth sits halfway between the nose and the chin. Add a guideline.

Divide the brow line into three equal parts for the neck; it should be at least as thick as a third of the head width but can be wider.

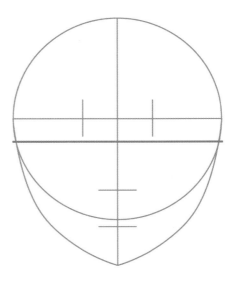

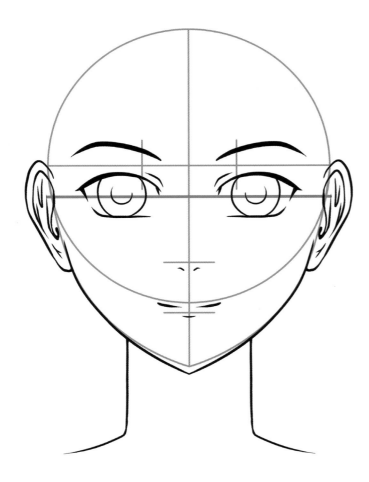

We'll cover these in more detail later, but for now, draw the eyes, eyebrows, nose, and mouth over the guidelines. To draw the sides of the face, follow the egg shape. The ears go between the brow bone and the nose. Draw the neck, making it about as long as the distance between the eyes and the mouth.

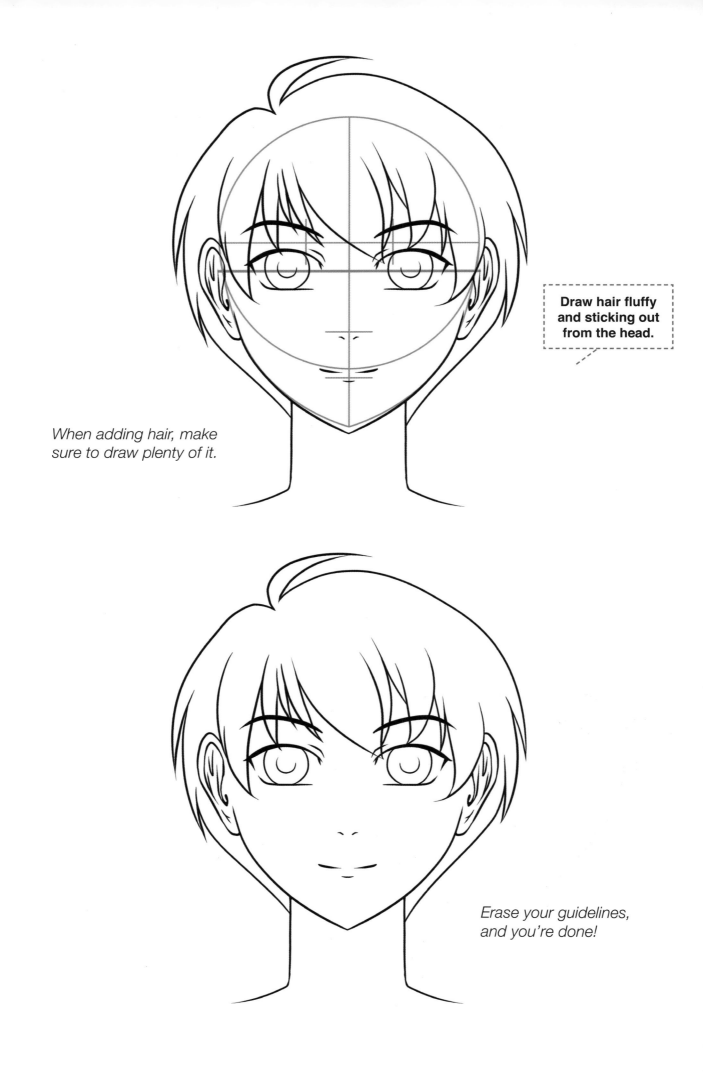

Draw hair fluffy and sticking out from the head.

When adding hair, make sure to draw plenty of it.

Erase your guidelines, and you're done!

PRACTICE HERE!

Try drawing facial features, the neck, and hair on the guidelines below.

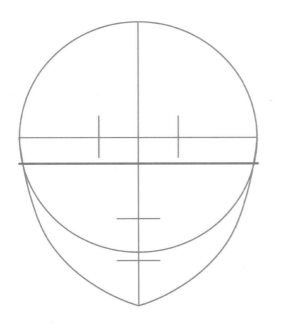

SIDE VIEW OF A FACE

Using what you learned about the front view, take the same guidelines and measurements, and draw a face in profile.

Start off with a circle for the skull, and cut it in half horizontally to form the brow bone.

This is when you need to start thinking sideways. The centerline now goes down the side of the circle. Join the back of the circle to the bottom of the centerline to form a pointed egg shape.

Eyes are positioned halfway down the head. Also add a guideline for the tip of the nose, halfway between the brow line and the chin, and draw the guideline for the mouth, placing it halfway between the nose and the chin.

Divide the brow line into three equal parts so you know where to place the neck. This will also help you position the ears, which go two-thirds of the way across the head.

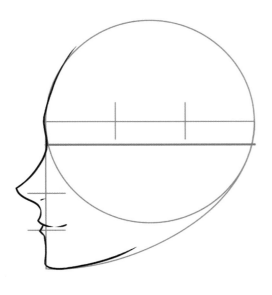

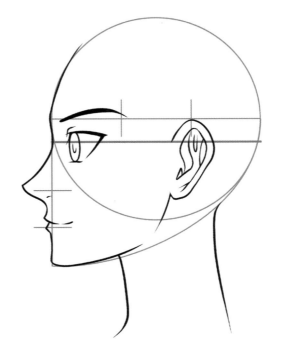

Draw the side profile. The forehead follows the curve of the circle and dips in at the eye line for the bridge of the nose. Line up the nose and the mouth with the guidelines for the eyeline, and draw the lips. Then add the chin.

The eyes in a profile are triangular. Draw the eyes halfway down the face, and vertically align the irises with the edge of the mouth. Draw the eyebrows on the brow line, and draw the ear two-thirds back. Add the neck.

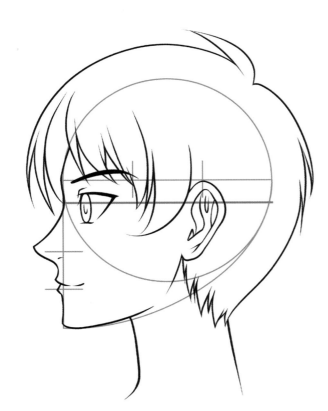

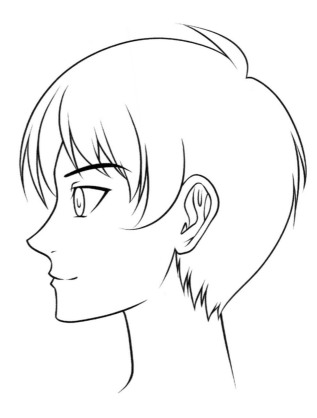

Add hair. Notice how the hair feathers onto the back of the neck.

Erase your guidelines, and there you go!

OTHER ANGLES OF THE FACE

It's easy to draw the basic shape of an egg and add guidelines on top, and then adapt this to draw faces in many different angles. It's just a matter of thinking in 3D!

LOOKING UP

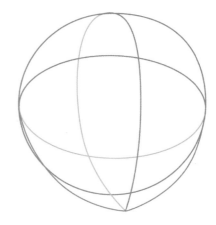

As you tilt the head up, the brow line still cuts the circle in half, but now it curves up in 3D, like the equator on a globe.

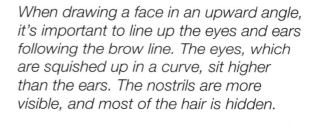

When drawing a face in an upward angle, it's important to line up the eyes and ears following the brow line. The eyes, which are squished up in a curve, sit higher than the ears. The nostrils are more visible, and most of the hair is hidden.

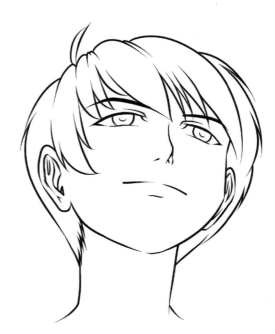

This boy is looking up with a slight smile on his face!

LOOKING DOWN

Curve the brow line down, and don't draw the centerline too long. In this downward-facing view, which is angled to the side, the chin shouldn't look too prominent.

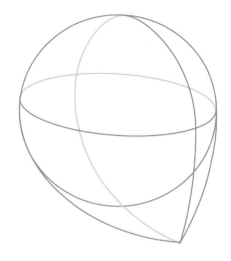

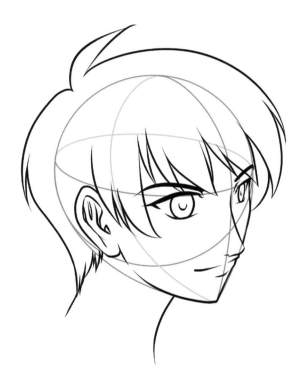

Because of the direction the character is facing, the facial features should be small, with the far side of the face almost not seen. The hair takes up most of this view.

This same boy looks more pensive when drawn looking downward.

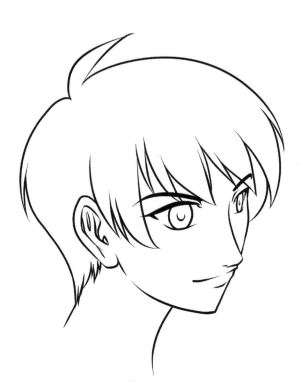

THE BODY

Artists often make the mistake of concentrating so hard on drawing the face that they don't leave enough room for the body. Try to imagine how tall the character is according to his or her head size, and then use a few quick measurements to ensure that all of the limbs are the correct lengths, and the joints are in the right places.

HOW TALL IS YOUR CHARACTER?

Try counting the number of heads you would need to stack on top of each other to equal a person's height.

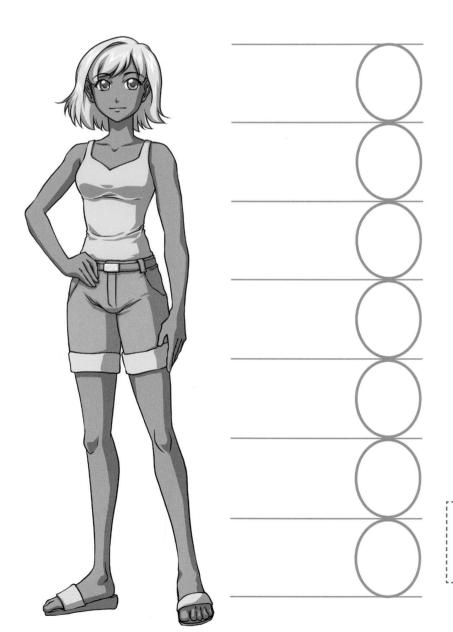

This young woman is seven heads tall. She has no trouble reaching the top shelf!

Children tend to be five or fewer heads tall. Adults are usually more than six heads tall, but they can be up to ten heads tall!

WIREFRAMES

Manga figures can be broken down into wireframes, or simple, connected circles and triangles. A wireframe will help you draw a figure in any pose.

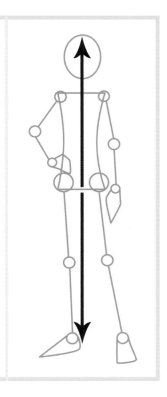

This teen boy is five-and-a-half heads tall.

USING STICK FIGURES

A drawing won't look good if the character's pose is wrong or if you haven't drawn his or her proportions correctly. Drawing stick figures, or wireframes, is a great way to practice.

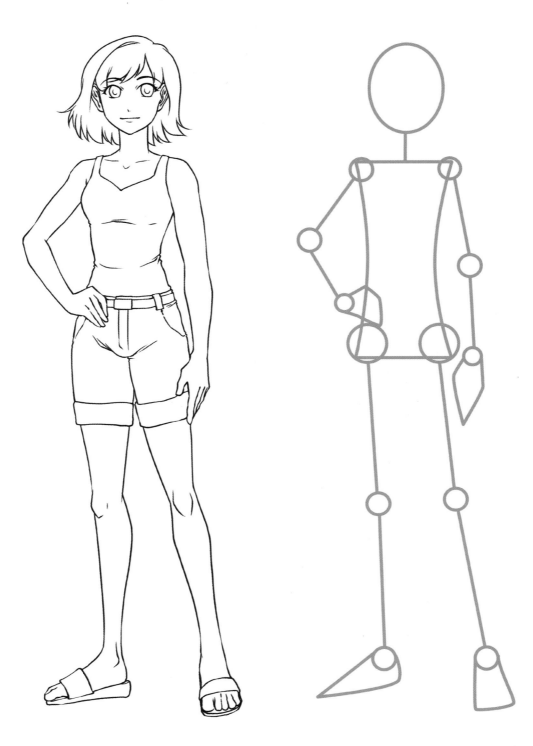

Use an oval for the head and a rectangle for the body. Mark out the main joints with circles to remind yourself where the limbs bend, and use diamonds and triangles to mark the hands and feet.

KEY RATIOS

Legs take up roughly half the height of a body, so don't draw them too short!

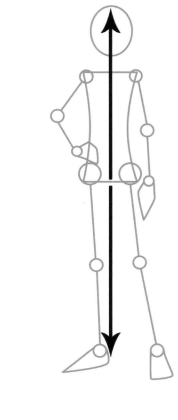

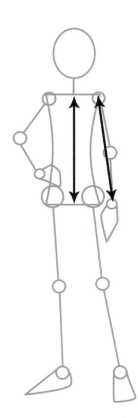

Arms are roughly the same length as the torso. The hands extend beyond the arms.

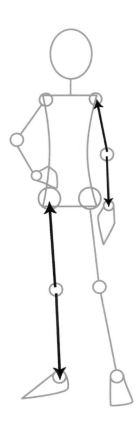

Elbows are halfway between the shoulder and the wrist. Knees are halfway between the hips and the ankles.

FEMALE BODY

Young male and female bodies look pretty similar in proportion and bone structure, but they change once puberty hits. Females will develop a bust, but the torso is weighted lower, with narrower shoulders and wider hips and thighs.

FRONT VIEW

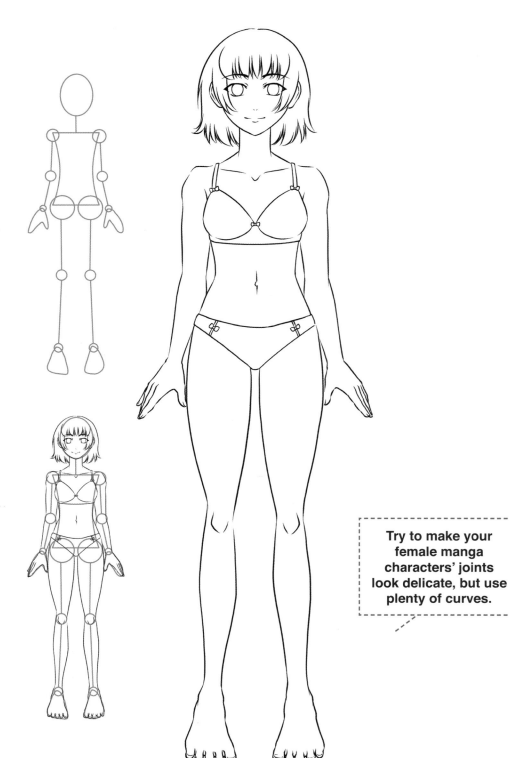

When drawing a stick figure, keep in mind that the shoulders should be only as wide as the hips, or narrower. The waistline goes about halfway down the torso.

Try to show females' delicate bodies in their wrists and ankles; these areas will always reflect bone structure.

Try to make your female manga characters' joints look delicate, but use plenty of curves.

SIDE VIEW

Remember that females' bodies store more fat, particularly in the lower body. In addition to a larger bust, females have more delicate bones and a narrower ribcage than males. In the sideways stick figure, make the torso narrow, and use a circle for the rear.

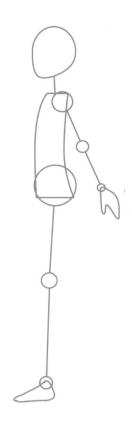

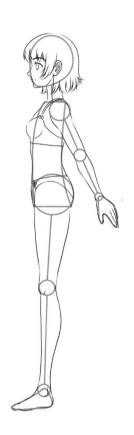

When fleshing out a sideways female character, the middle section should stick out in a rounded shape.

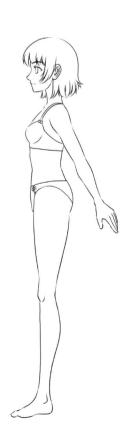

Because females tend to have less muscle tone than males, use gentle curves throughout.

For a realistic-looking female manga character, pay attention to real-life women's proportions.

PRACTICE HERE!

Draw the detailed lines of a female body over these stick figure guidelines.

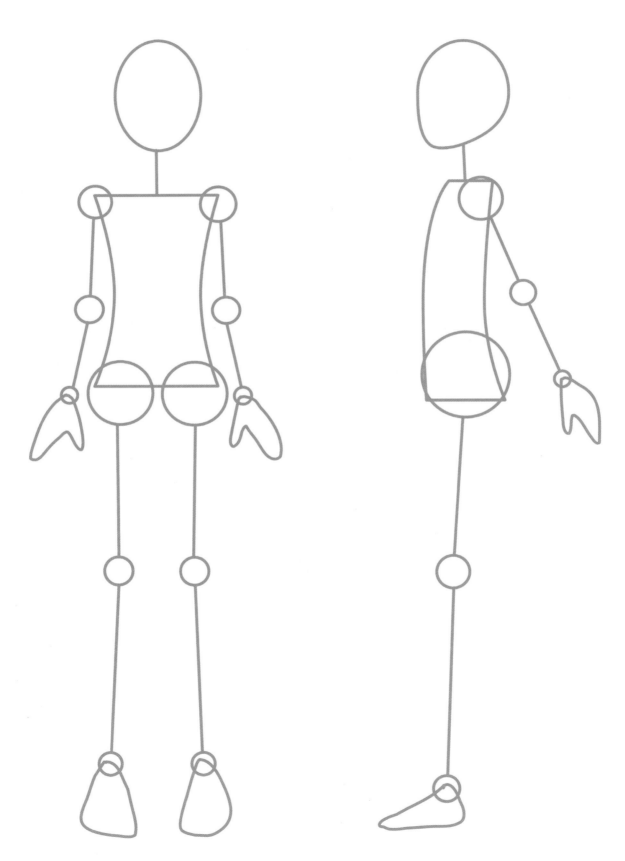

MALE BODY

Male characters tend to be larger and more muscular than their female counterparts, and their weight is distributed differently. Males are more top-heavy, with less-defined waists and narrower hips.

FRONT VIEW

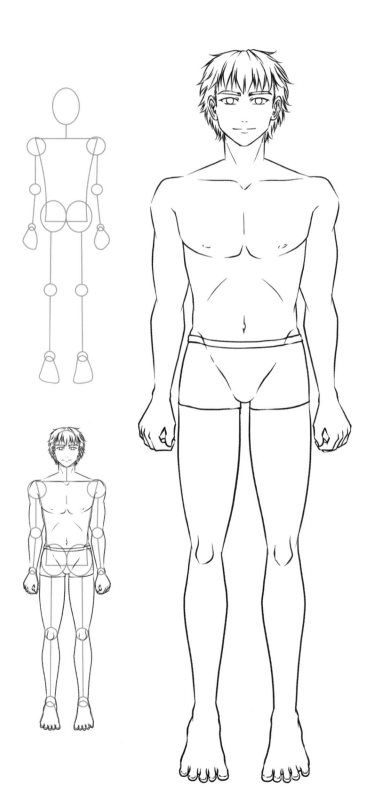

Draw a stick figure with wide shoulders and narrow hips. You may need to draw adjoining ovals to use as guidelines for the hips.

Use straighter lines and sharper angles to draw the outlines of the neck, shoulders, muscular upper arms, chest, and hips.

SIDE VIEW

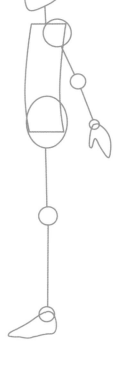

The side view of a male body still shows broad shoulders, a ribcage, narrow hips, and a rear. Use a thicker rectangle for the torso and an oval for the rear.

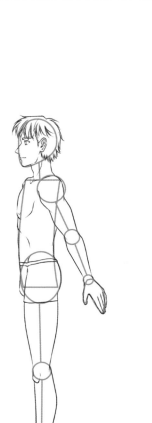

A man's bust usually doesn't stick out. The ribcage is wide, and the waist is straight up and down.

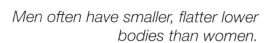

Men often have smaller, flatter lower bodies than women.

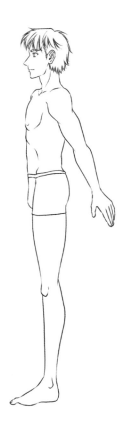

PRACTICE HERE!

Draw the detailed lines of a male body over these stick figure guidelines.

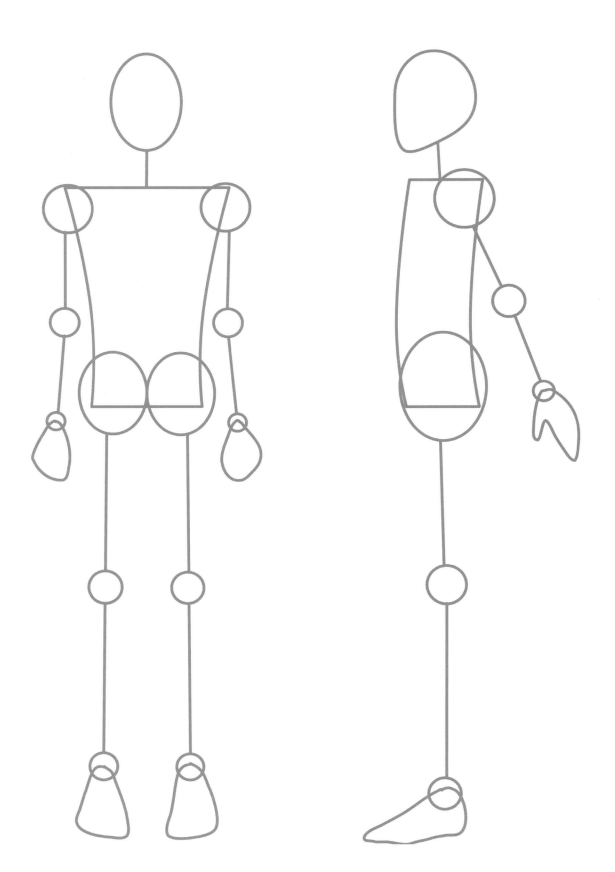

POSE LIBRARY

Now that you've learned how to draw a manga body, it's time to add poses. Notice how each drawing here starts as a basic stick figure that captures the essence of the pose and marks the length of the limbs and joints. More details are added to create a finished picture.

WALKING

Make sure your figure looks balanced, straight, and upright. Remember that walking always requires having one foot on the ground.

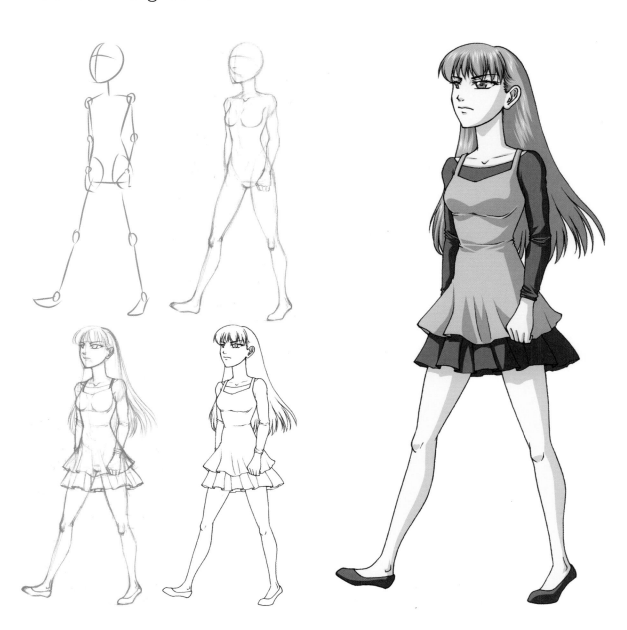

SITTING

Decide whether you want your character to lean forward or backward while sitting. What does she do with her hands? How does she position her feet?

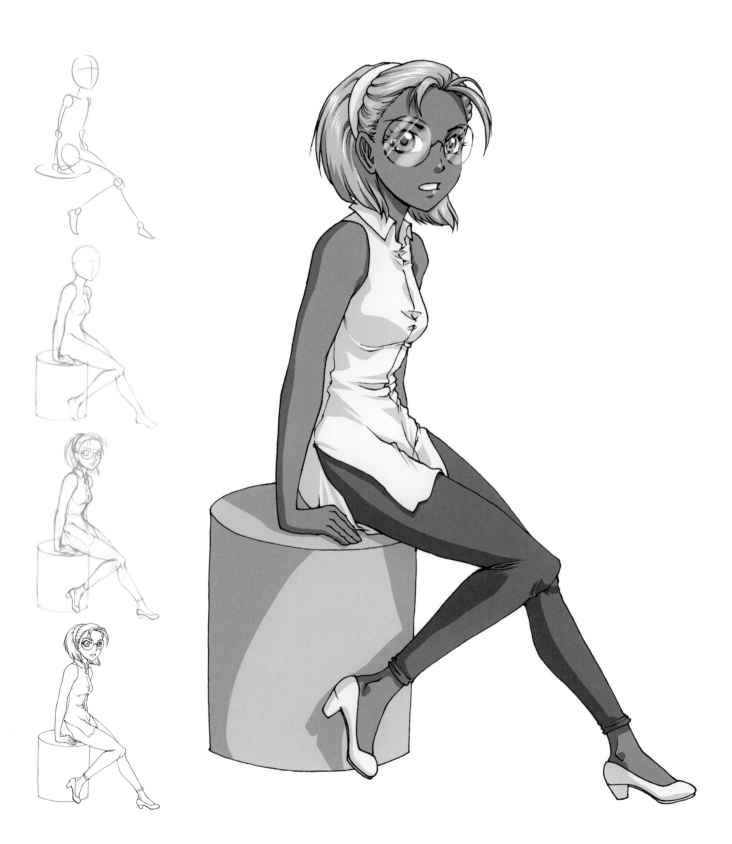

RUNNING

A character must lean forward while running. His hands and legs fly in opposite directions, and his body twists as he lifts his legs and swings his arms.

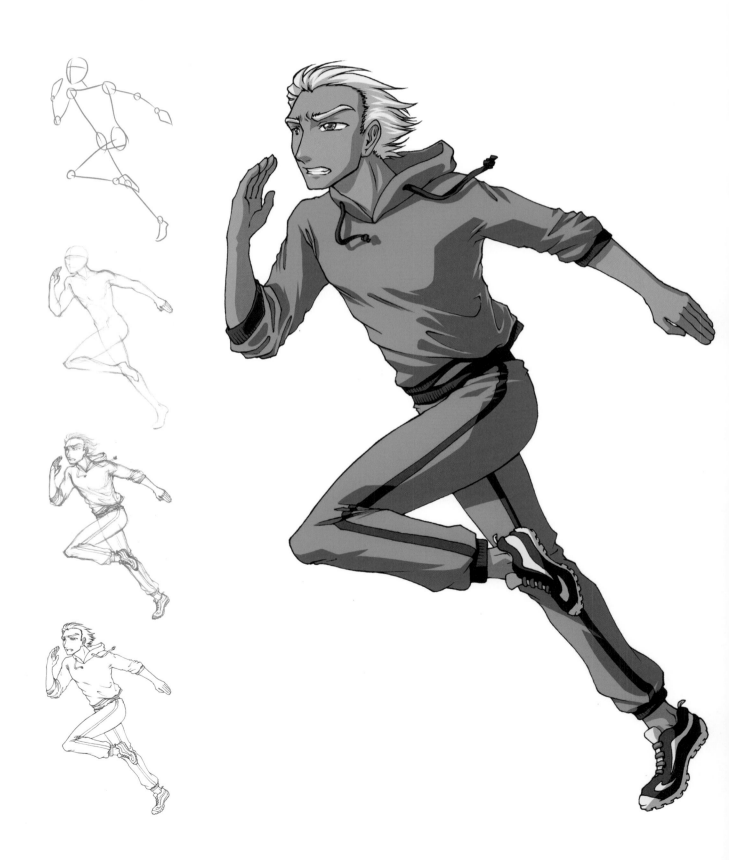

JUMPING

When your character leaps high into the air, her legs may be bent or straight and her body curved backward or forward, depending on how far into the jump she is. Remember to ruffle her hair and clothes!

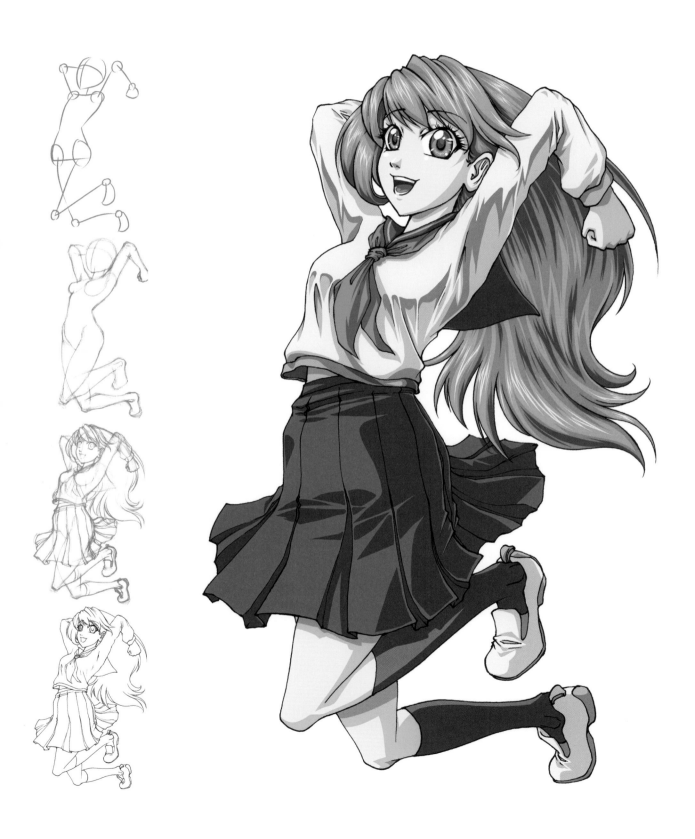

CROUCHING

A crouching figure leans forward with his legs bent near the ground. It's uncomfortable to stay like that for very long, so consider what a young man might do to make this pose easier.

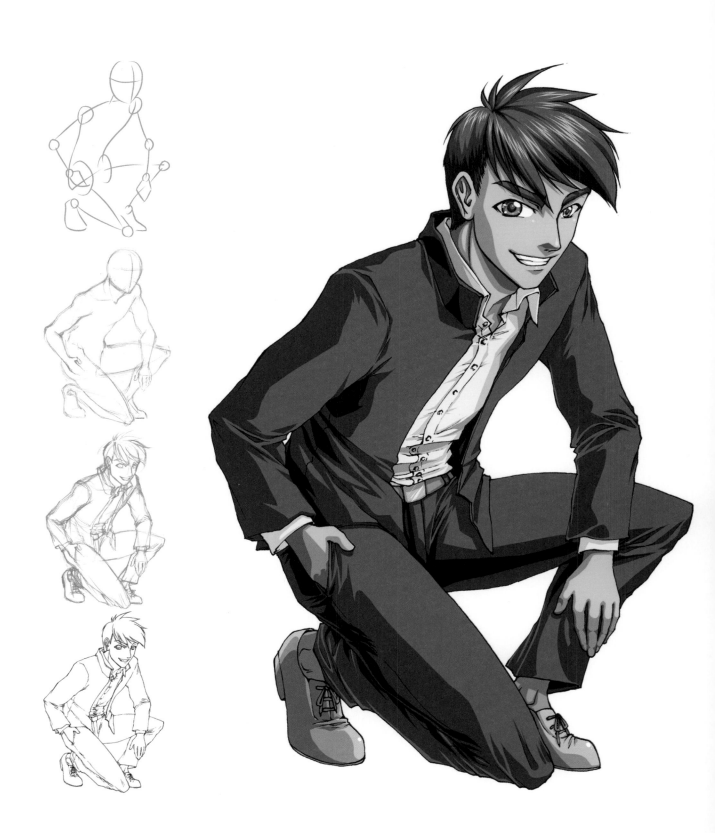

PRACTICE HERE!

Practice drawing one of the poses you've already seen, or invent a new one. Look at real-life people around you for inspiration!

FACIAL EXPRESSIONS

Conveying their feelings and emotions can be the best part of drawing manga characters. With just a few changes to the eyebrows eyes, and mouth, you can make them laugh, cry, or rage!

NEUTRAL

This face has a neutral expression. The eyebrows are relaxed and straight, the mouth is also relatively straight, and the eyes are open at full size.

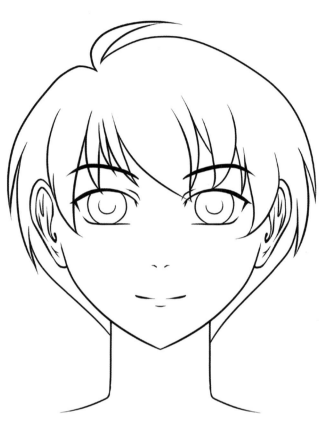

HAPPY

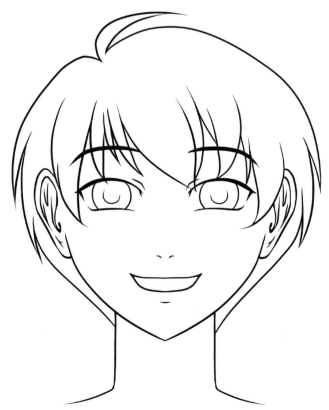

When a character is happy, showing a smile is key, whether you draw just a slight upturn at the corners or a big, wide grin. The eyes are often creased. See how the bottom eyelash line is upturned? Eyebrows can also be raised slightly.

SAD

Knitted eyebrows that angle upward in the middle form the main feature of a sad expression. You can also add a mouth with downturned edges to match.

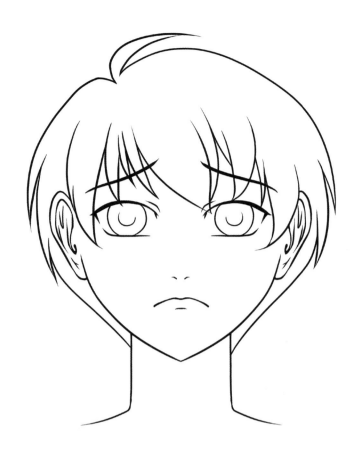

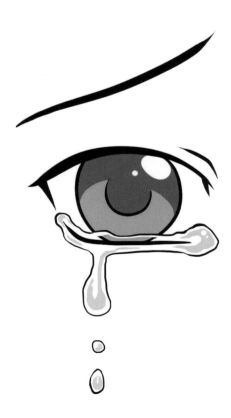

If you want to draw a character crying, use a light touch for his or her tears. Keep the lines thin, perhaps leaving a few gaps, so that they have a transparent appearance. It helps to shade sparsely in light gray-blue colors, and add white reflections on top to create a glistening look.

ANGRY

Eyebrows expressing anger form sharp, downward angles. Eyes tend to narrow when someone looks angry, and the mouth curves down at the edges. You can show gritted teeth as well.

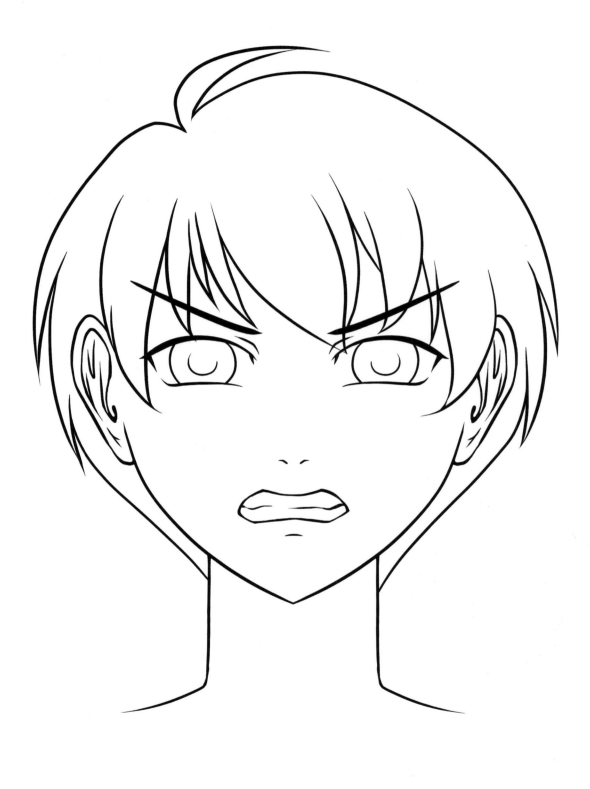

PRACTICE HERE!

Try drawing facial expressions on the guidelines below.

SUBTLER FACIAL EXPRESSIONS

There are plenty of other feelings and emotions besides the basic ones. What if your character is shocked? Maybe he is embarrassed about something, or perhaps she feels suspicious of what a friend has said. How about if your character is furious with someone? Try using different combinations of eye, eyebrow, and mouth shapes.

SHOCKED

The most important features here are the eyes. Show the whites of the eyes, and draw very small pupils. Raised eyebrows and an open mouth complete the look.

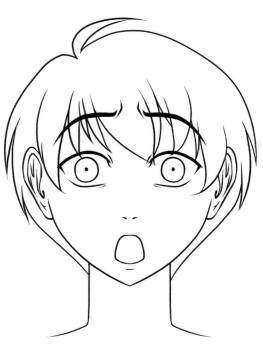

EMBARRASSED

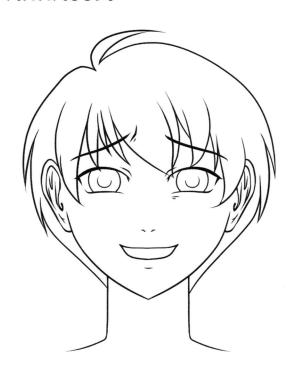

Draw the eyebrows angled upward in the middle, adding a bit of tension to convey concern. The crinkled eyes and smiling mouth should look happy, so the character looks like he's trying to reassure you.

SUSPICIOUS

It's key that you get the eyebrows right. When a person isn't sure whether to believe something, he or she might raise one eyebrow. Narrowed eyes and a straight mouth make the character look cool and distant.

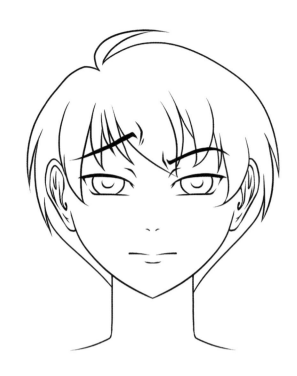

FURIOUS

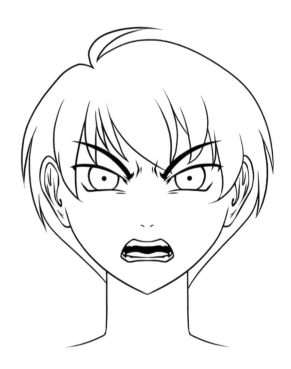

Using the angry face on page 50 as a guideline, make your character look even angrier by lowering his eyebrows until they touch his eyes. Give the eyes a more angular shape. Drawing an open mouth to make it look like he's shouting really adds fury to your manga character!

Drawing wrinkles on a face is a great way to add tension to the face. This is most effective on angry faces.

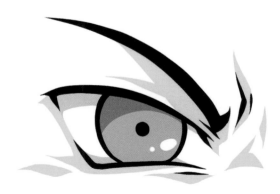

VISUAL GRAMMAR

Sometimes facial features don't sufficiently convey exactly how a character is feeling, particularly if you're drawing a comic strip and want some slapstick comedy. Like a light bulb appearing when you have a bright idea, manga artists also use symbols called "visual grammar" to represent certain emotions and thoughts.

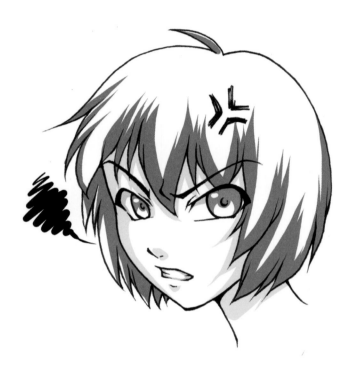

This female character is very angry, so there's a black cloud near her and a stress mark on her forehead.

This boy looks like he's been caught by someone who discovered that he didn't do something he was supposed to do. He has a spark symbol and a drop of sweat on his forehead. Uh oh!

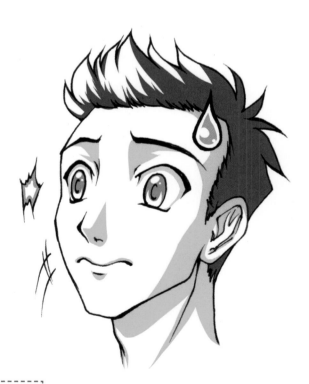

Manga artists draw a drop of sweat on the forehead to indicate that a character feels embarrassed, bashful, nervous, or worried.

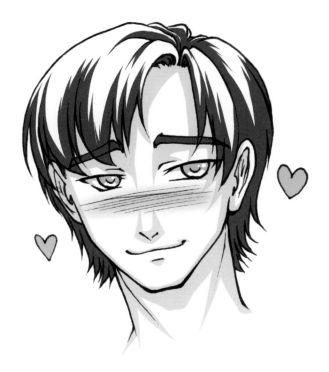

It's common across all styles of comic artwork to draw heart shapes near someone who's looking at the object of his or her desires. This blushing guy is obviously head over heels for someone!

When a character hangs her head in despair, she tilts her face downward and her eyes become dark and shadowed. Manga artists simplify that by using vertical lines. When a manga character feels really sad, she is believed to attract ghosts. These eerie floating clouds represent lost spirits.

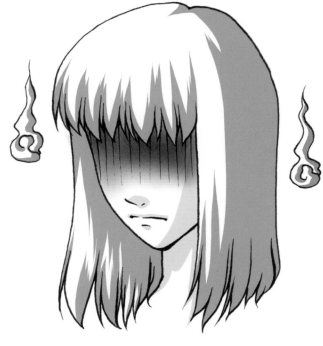

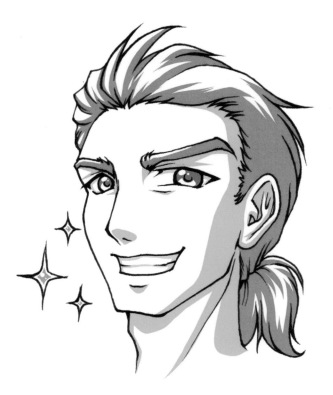

This man displays a bold and confident grin, showing off his pearly white teeth. The sparkles add a comic effect as though he's really laying on the charm!

CHARACTER DESIGN

Characters can have many different face shapes, hairstyles, and body types. There are also tons of clothing and accessory options! Make sure your characters are cohesive. Ask yourself: Do their facial features and hairstyles reflect their personalities? Are they dressed suitably for their locations and roles?

WHAT DOES THE FACE SAY?

A character's face can indicate his or her age and demeanor. For example, large, round eyes convey youth and innocence, and a small, pursed mouth looks solemn and critical.

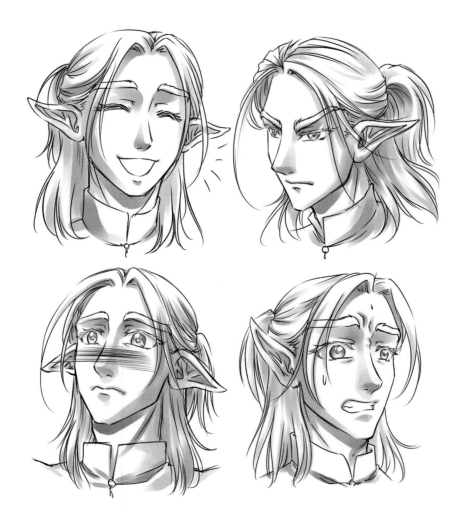

HOW ABOUT THE HAIR?

A timid person may hide behind his or her hair, while a no-nonsense practical person likely has a short, low-maintenance cut.

BODY TYPE BASICS

A weight lifter needs strong muscles, and a long-distance runner is leaner. Some women are curvy, while others look boyish. Think about whether a character's build is appropriate for his or her lifestyle.

ADDING CLOTHING, PROPS & ACCESSORIES

Think about setting before adding clothes to a character. Then decide if the clothes fit what he or she does for a living.

DECIDE THE COLOR SCHEME

Colors help convey messages about clothing and what it signifies to the wearer. For example, white can mean innocence and purity. Black may be very formal. Blue and purple are often associated with royalty.

FINALIZE THE DESIGN

Once you've decided on your character's full look, draw a clean front and back view of him or her, and color the drawing cleanly so you can use it as a reference.

INNOVATE WITHIN REASON

Strive to create characters that make sense within the context of your manga. Try to immerse yourself in your character's role and setting so that he or she calls the shots.

FACE SHAPES & STYLES

Look around, and you will notice that everyone's face is shaped differently. Manga is very stylized, but every artist has his or her own way of drawing. By concentrating on your characters' cheeks, jawlines, and chins, you can show different face shapes in your drawings.

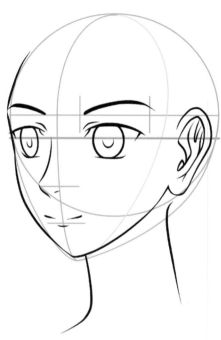

This character has a slim face, with less prominent cheeks and a pointed chin.

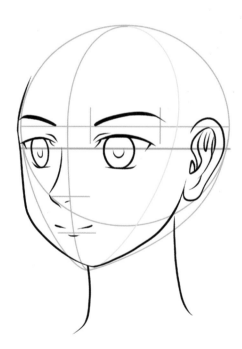

This face looks younger. The chin is smaller, and the cheeks are rounder.

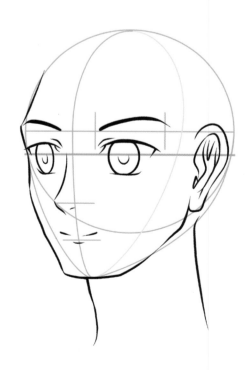

This face has a strong bone structure. Note the high cheekbones and hollow cheeks and the way the chin and jaw stick out.

PRACTICE HERE!

Try drawing different face shapes using these guidelines. Would you like your character to have a round, young-looking face or something more mature?

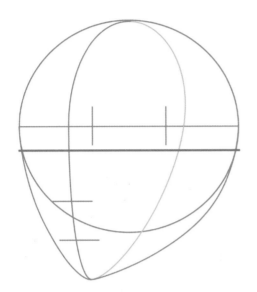
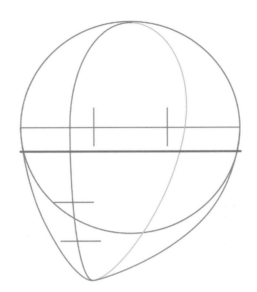
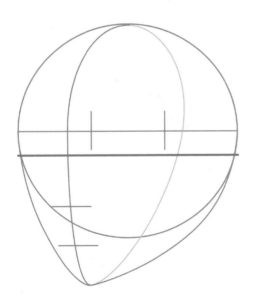
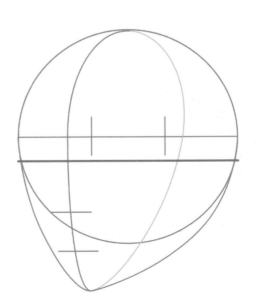

STYLING THE EYES

Draw your characters' eyes in different styles, but make sure they suit the person. You can color and shade eyes in different ways too. Try these examples!

DIFFERENTIATING EYES

Think about what your characters' eyes say about his or her personality.

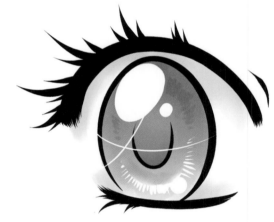

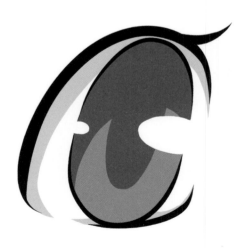

This eye is almost triangular with a sharp, pointed edge at an upward angle. This gives the character intensity and a cool, aloof feel.

These big, round eyes make the character look young, wide-eyed, and innocent, and the eyelashes and sparkly highlights add beauty.

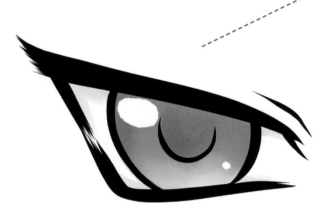

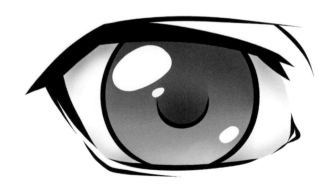

This eye is more angular. The eyelid's folds and the lines at the eye's corners convey a sense of maturity.

This eye feels very young, but it's drawn and shaded in a simpler style. Its bold, clean look would suit a young boy or girl in a children's comic.

COLORIZING THE EYES

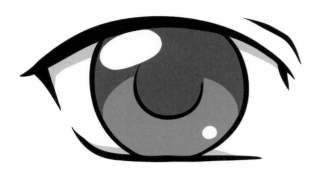

There are many ways to add color to eyes, but it can help to follow certain rules. Pupils are dark, whereas irises fade from dark to light and from top to bottom. The big highlights tend to go in the top corner of the eye, matching the light source. Don't neglect the whites of the eyes; use blue-gray shadows at their edges.

This shows you how to really take it to the next level! You can add interest to the eyes using certain elements, such as increasing the contrast with darker shadows, shading in an iris pattern, and adding highlights.

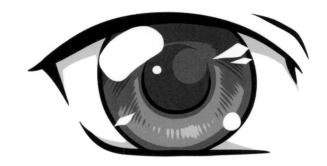

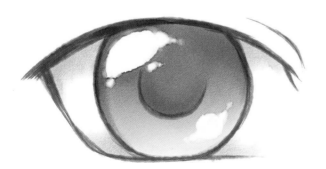

You can also soften the lines and colors. This eye is drawn in a watercolor style, with hazy pencil lines and blurry colors fading in and out.

NOSES & MOUTHS

Manga is a very minimalistic art form that emphasizes certain features, like the eyes, while downplaying the nose and mouth. Manga artists have to hint at so much using so little, so focus on the darkest shadows and lines.

KNOW THE NOSE

For a frontal view of the nose, stick to drawing just the nostrils or the shadows cast by the nose.

 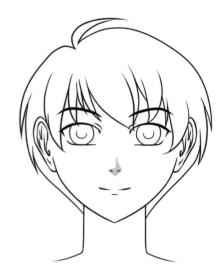

NOSES FROM THE SIDE

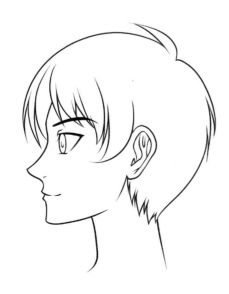 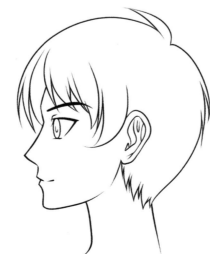 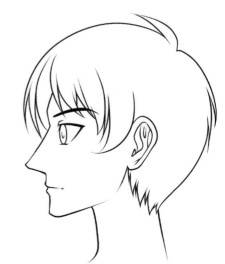

MASTERING THE MOUTH

Mouths are also drawn in a minimalistic style. Focus on the mouth's opening and defining the lower lip, and avoid outlining the full shape of the lips.

A closed mouth features a long black line for the opening. You can hint at the lips' shape by adding curves in the center and a small curve below for the lower lip. Add shadows to match.

When shading and coloring in lipstick, the upper lip should be darker, and you can add glossy highlights to the lower lip.

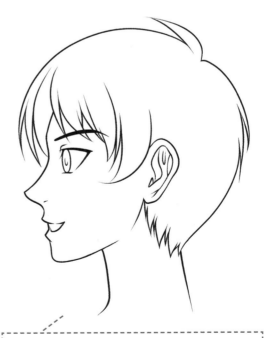

Don't define every tooth; just draw the line where they all meet. Shade the edges of the teeth with blue-gray.

When drawing a side view of an open mouth, the jaw moves down to match the width of the open mouth.

SHORT HAIRSTYLES

Let's take a closer look at drawing hair, beginning with short styles. When drawing short hair, challenging spots will include the hairline and the back of the head. Use lots of small spikes and strokes where the hair meets the head. Short hair sits close to the base of the skull.

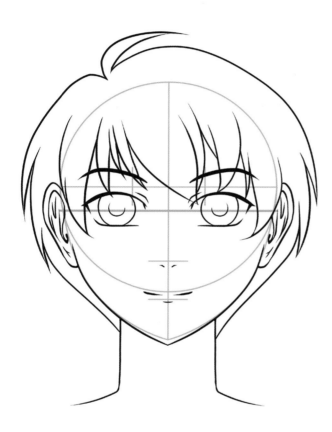

Many short hairstyles have a spot (or two!) at the top and crown of the head from which the hair flows. Make sure your lines follow the direction of the hair flow.

Very short hair is often swept back and up from the face, leaving the hairline visible. Use small strokes along the edge where the hair meets the forehead and temples.

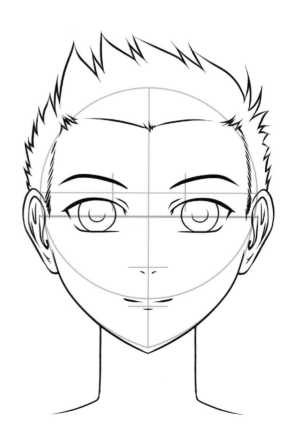

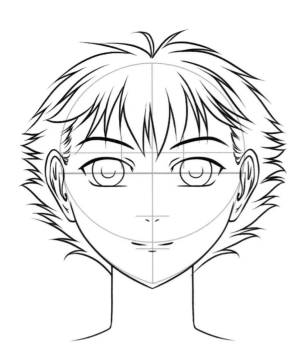

Spikes are a great, simple way to draw hair. They can go up or down depending on how they're styled and how much hair gel you use! Try using different widths for the spikes so they look real.

To draw this super-sleek style, make sure the hair has a razor-sharp edge. The hair at the nape of the neck is closely trimmed.

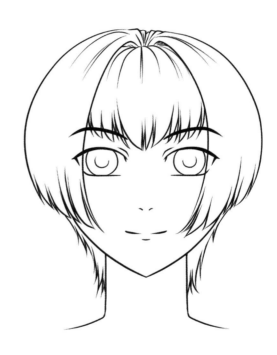

To make hair look more realistic, use separate strokes when drawing each line, and flick the pen or pencil upward to form sharp, tapered lines.

LONG HAIRSTYLES

Long hair gives you more versatility for styling and accessorizing. Here are some examples. As always, think carefully about your lines.

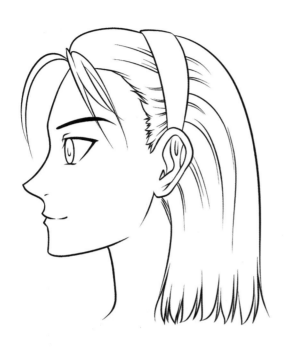

When a person wears a headband, it pulls the hair back from the face and makes the direction of the hair go straight up, back, and into the headband. Add a couple of loose strands at the front to soften the look.

Ponytails are difficult to see from the front unless they're very high on the head.

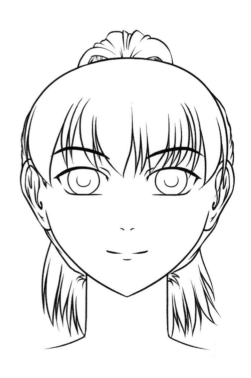

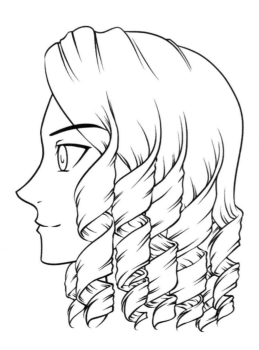

Glamorous curls are a lovely way to style long hair. Draw sections of hair leading into long columns of spiral curls.

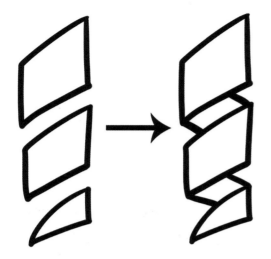

Spiral curls might seem impossible to draw at first, but they're actually very easy. Draw slanting rectangles pointing downward in a column, and connect them to the strokes going the opposite way.

When drawing braids, be careful with the lines. You will need to keep track of how each section weaves in and out of the braid.

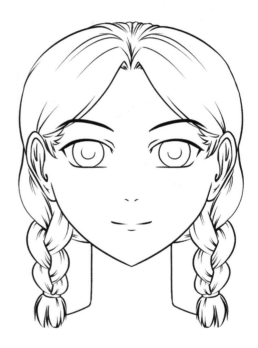

Try braiding some ribbons to better understand how to draw braids!

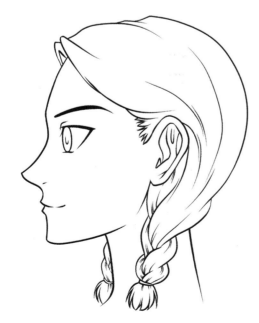

PRACTICE HERE!

Try drawing some short hairstyles using these guidelines.

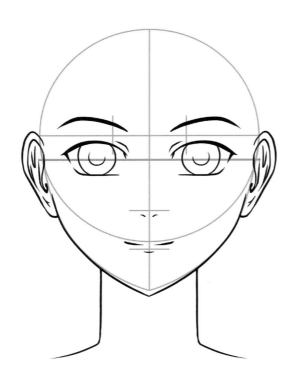
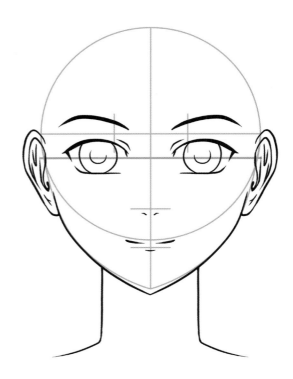
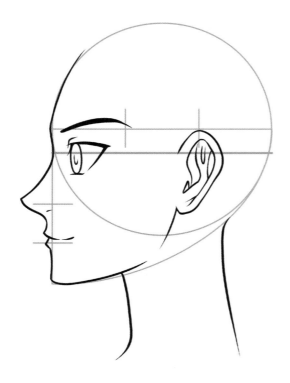
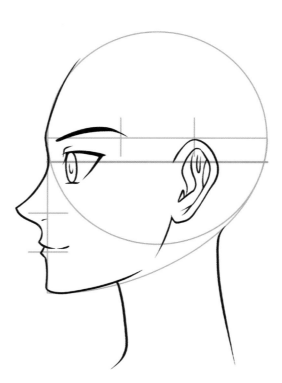

Now draw some long hairstyles.

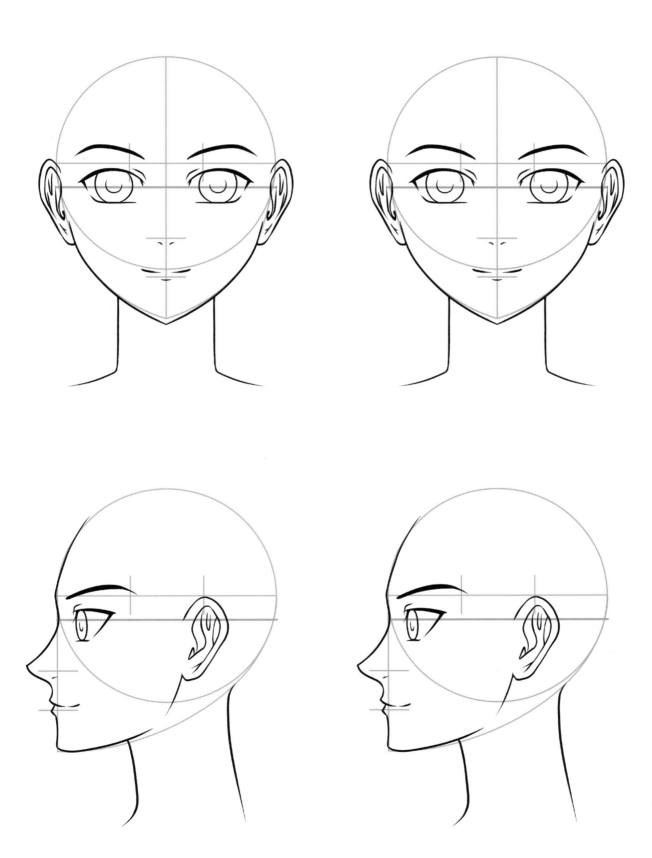

CONTRASTING BODY TYPES

In real life, people come in different shapes and sizes, with varying builds and body types. You can try drawing different body types too; it's boring if all of the characters look the same! Here are a few examples to get you started, but don't feel restricted! Look around you for inspiration.

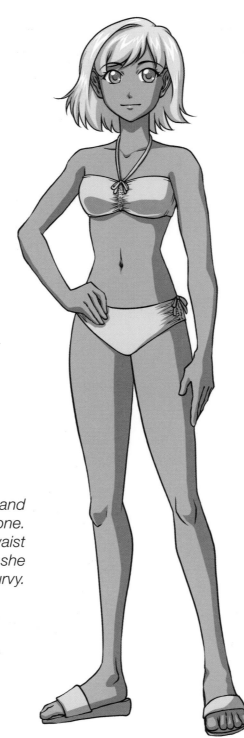

What other body types aren't shown here? Draw some!

This female character is tall and slim, with strong muscle tone. Although she has enough waist definition to look feminine, she is not very curvy.

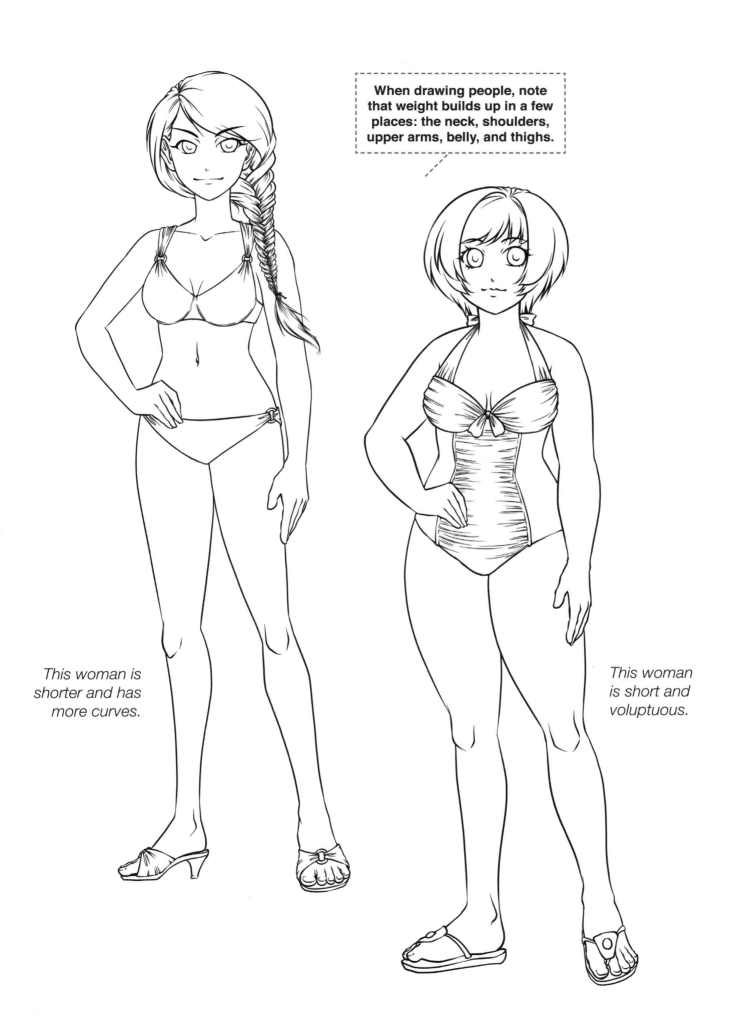

When drawing people, note that weight builds up in a few places: the neck, shoulders, upper arms, belly, and thighs.

This woman is shorter and has more curves.

This woman is short and voluptuous.

MALE BODY TYPES

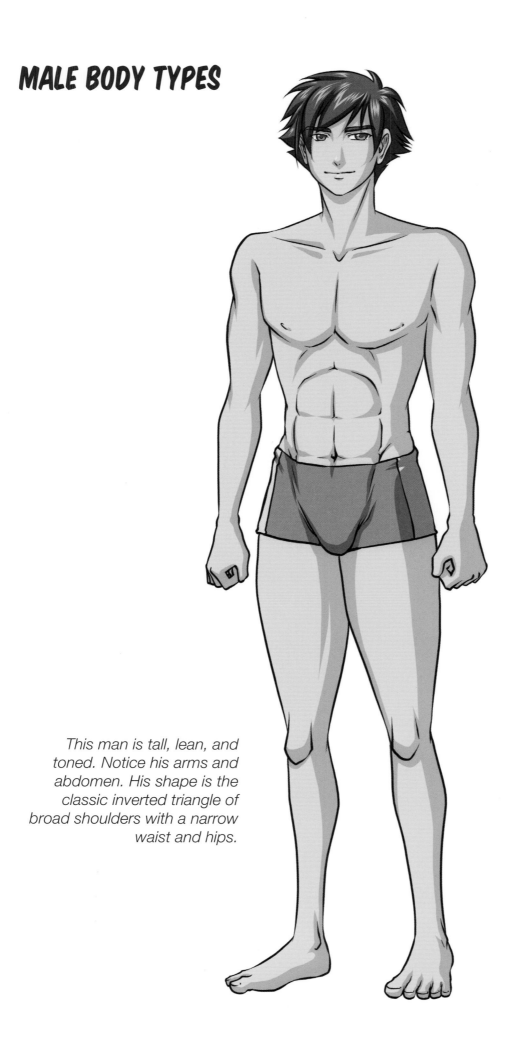

Look all around you for drawing inspiration! Try drawing friends and family in the manga style.

This man is tall, lean, and toned. Notice his arms and abdomen. His shape is the classic inverted triangle of broad shoulders with a narrow waist and hips.

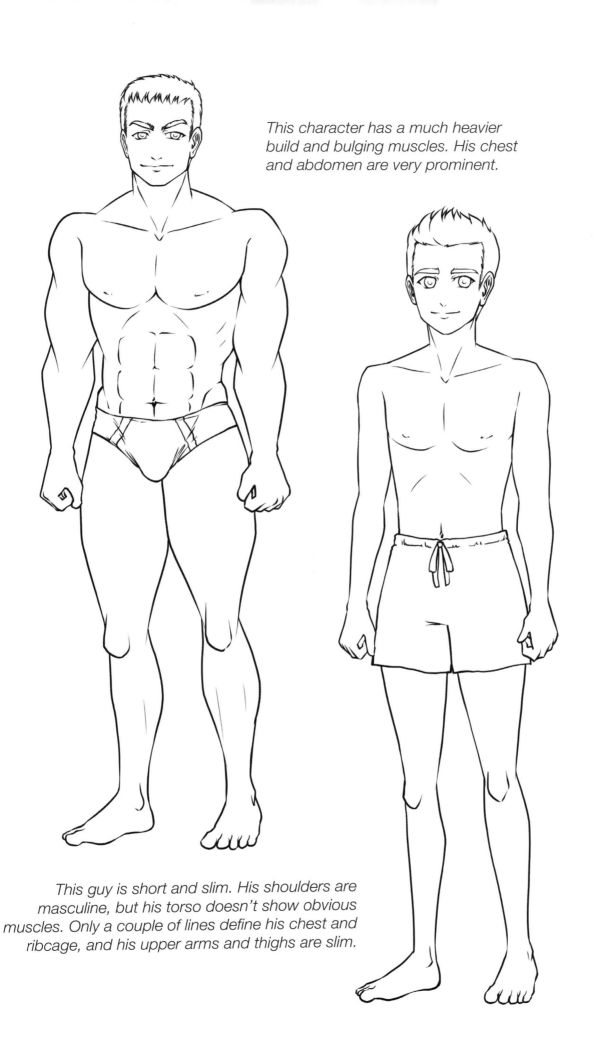

This character has a much heavier build and bulging muscles. His chest and abdomen are very prominent.

This guy is short and slim. His shoulders are masculine, but his torso doesn't show obvious muscles. Only a couple of lines define his chest and ribcage, and his upper arms and thighs are slim.

CREATING CLOTHES

The biggest mistake beginning manga artists often make is attempting to draw clothed characters without first sketching and visualizing the bodies underneath. It is absolutely crucial first to picture a character nude so that you can correctly layer the clothes on top.

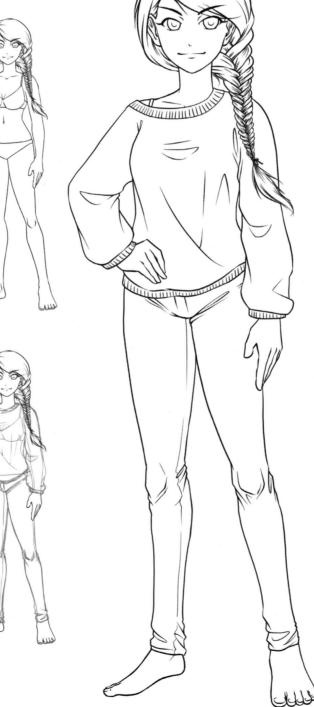

Start off with a character wearing only close-fitting underwear.

When adding clothes to a character's body, keep in mind that fabric adds a bit of bulk. Then think about where the cloth will drape and crease; in this case, it's at the character's bent arm and her bust.

A sweatshirt is made of fairly thick material, but it's soft and baggy. It hangs off her arm, gathering at the ends of the sleeves, and it drapes from her bust to the hem. Her skinny jeans are tight but retain creases around her joints, such as the knees and ankles.

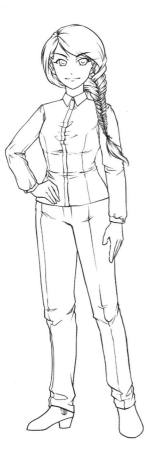

This woman's shirt is made from crisp cotton, and its close-fitting seams follow her curves. Some areas—such as her bust, waist, and elbows—show creases. Her pants are looser around the knees, gathering a little at the ankles.

Made from a silky, slightly stretchy jersey, this wrap dress is pulled tightly around her body. See how the excess fabric gathers at the shoulders and pulls tautly over the mid-section before gathering at the side. The skirt flows downward, forming billowing ruffles at the bottom.

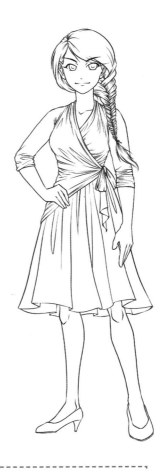

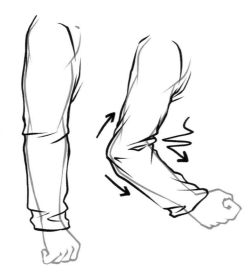

To draw realistic creases, think about which areas show tautness and tension, like the elbow. Use straight lines moving away from those points. Areas with excess fabric, like the inside of the elbow, gather.

For a graceful hemline, draw the end of the fabric first as a wavy line, and then draw lines leading up from each of the tight curves.

PRACTICE HERE!

Practice drawing different outfits on these characters.

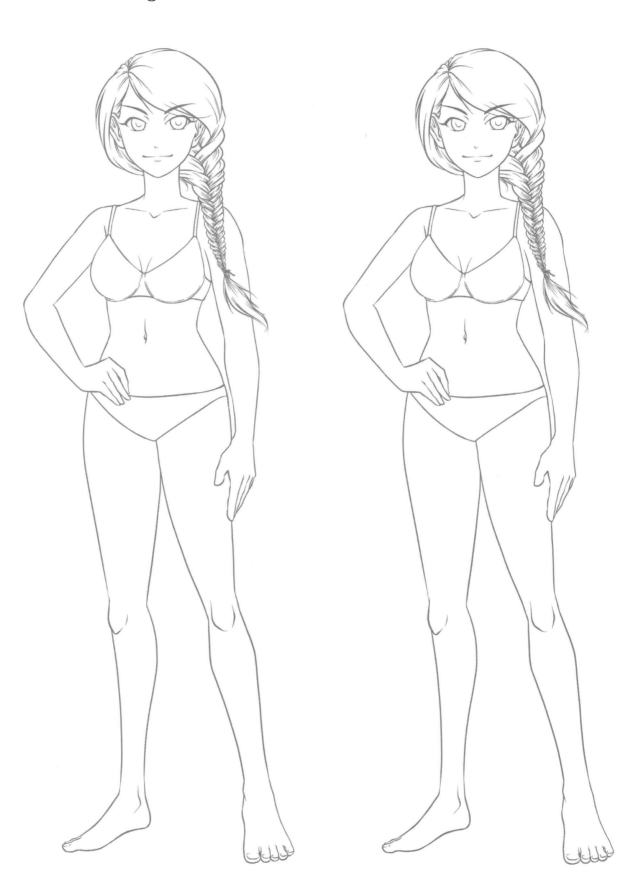

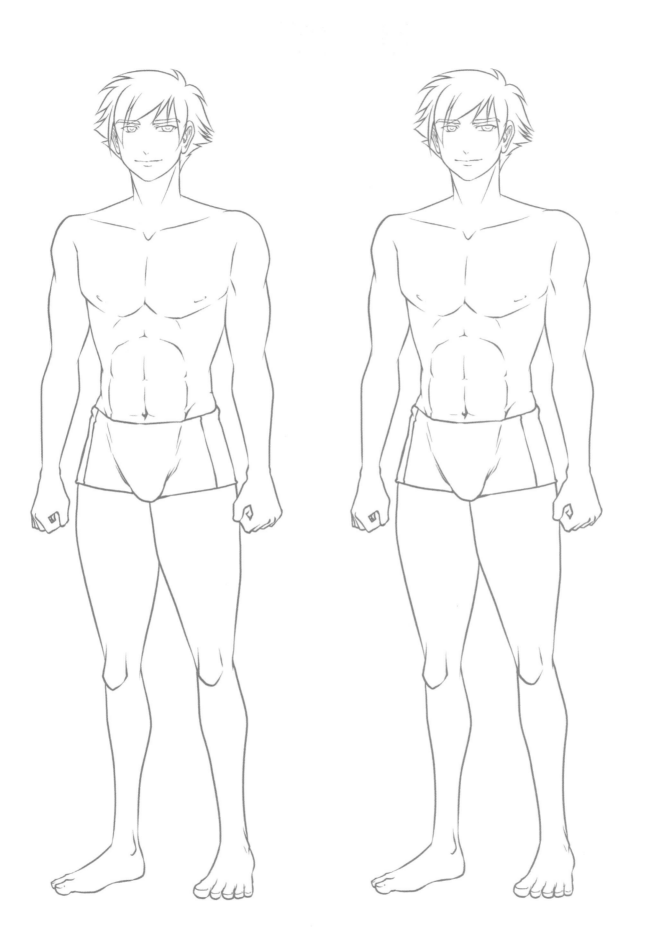

ACCESSORIZING

Adding accessories is a great way to give your character a unique look, and it can convey what kind of person he or she is, his or her hobbies, and even the season!

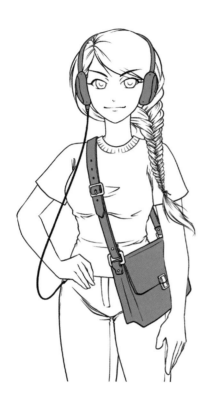

It's rare to walk down the street without seeing someone wearing headphones. People often carry bags to hold their laptops, gaming devices, and other gadgets.

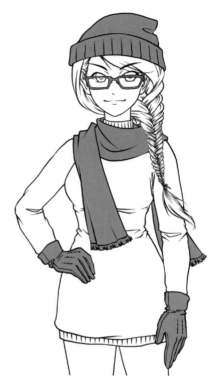

Sometimes people wear accessories out of necessity!

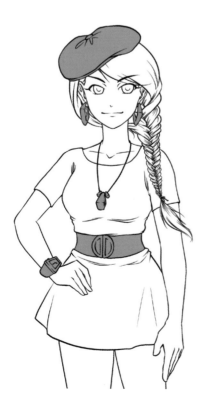

Hats come in different styles. Belts are not only useful for holding up a pair of jeans; they can also cinch the waist. Watches are both useful and fun!

This elegant outfit demands exquisite accessories to match! Her necklace, earrings, brooch, and belt drip with pearls and gemstones. Her look is made even more feminine with the flowers in her hair.

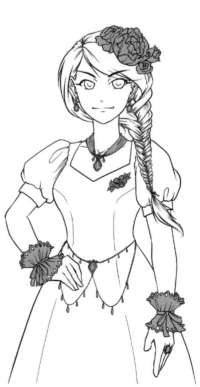
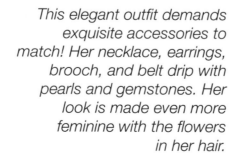

PRACTICE HERE!

Try designing some accessories of your own. Here are some character templates for you to embellish with jewelry, hats, and other fun extras.

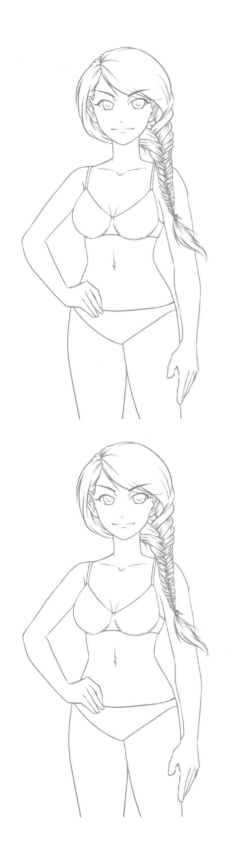

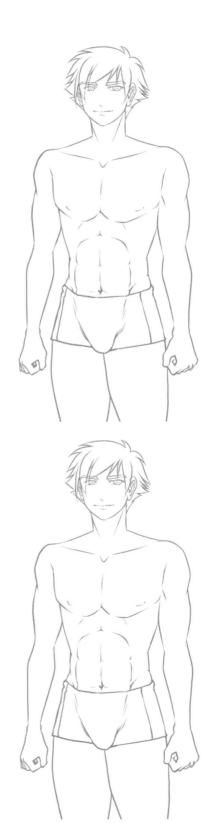

STYLING CLOTHES

Even though many of us wear clothes that are similar or identical, everyone wears clothes in different styles. Think about the different ways you can wear something like this school uniform.

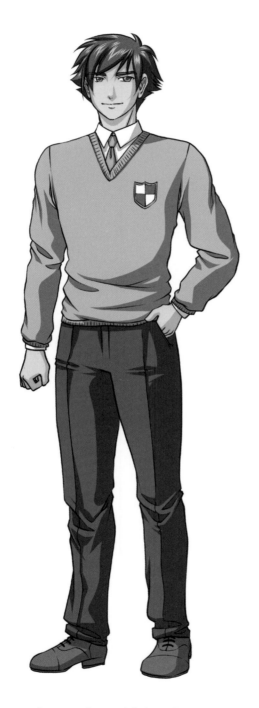

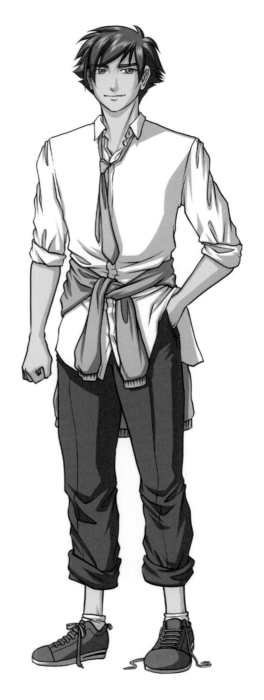

This guy is wearing a high school uniform absolutely according to the rules. His shirt is buttoned up and tucked into his pants, and his tie is neat and straight.

It's a hot day outside, the school bell has just rung, and he's heading to the mall but doesn't have time to go home and change. He wears his uniform in a much more relaxed manner.

PRACTICE HERE!

Imagine this high school student has to wear the uniform below.
How would she style it?

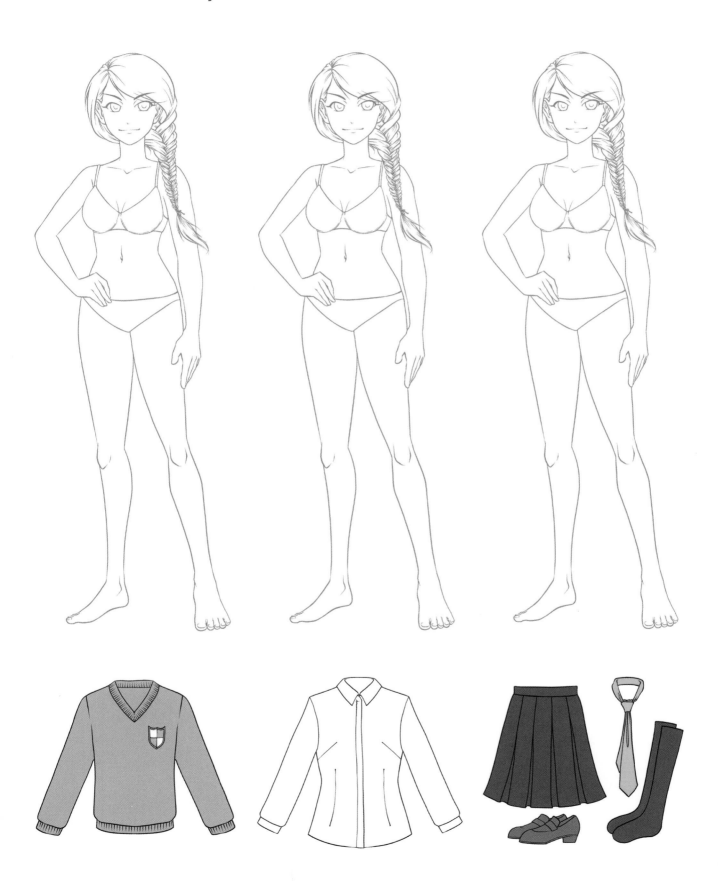

HISTORICAL & TRADITIONAL CHARACTERS

Some of our best-loved stories come from the past, and creating characters from long ago is a wonderful way to immerse your readers in another world. Here is a small selection of contrasting styles and silhouettes to study. Observe how the clothing is cut and sewn as well as how the props and accessories are used.

COLONIAL SETTLERS

Life in the harsh New World required European settlers to keep their clothes practical and comfortable. They wore rugged and easily mended clothing consisting of many layers.

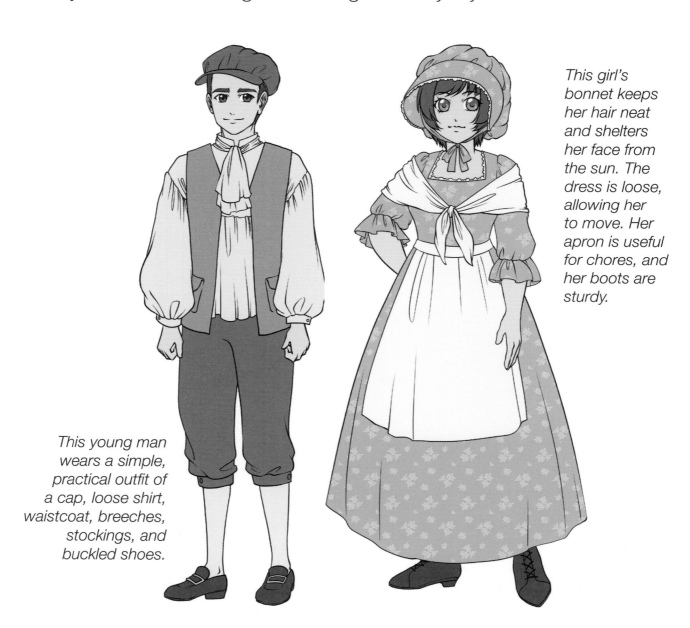

This girl's bonnet keeps her hair neat and shelters her face from the sun. The dress is loose, allowing her to move. Her apron is useful for chores, and her boots are sturdy.

This young man wears a simple, practical outfit of a cap, loose shirt, waistcoat, breeches, stockings, and buckled shoes.

ENGLISH GENTRY DURING THE REGENCY ERA

Jane Austen fans love the Regency era, which lasted from 1811 to 1820. During this time, England was known for its dashing gentlemen and elegant, romantic dresses.

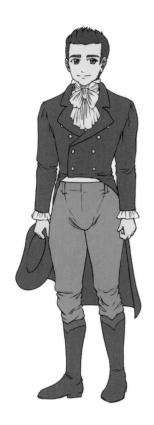

Men wore their clothes tightly tailored to show off their figures, but they also needed to dress practically for gentlemanly pursuits like horseback riding. This silhouette features many embellishments.

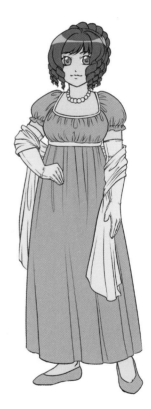

Ladies abandoned their corsets and heavy gowns in favor of looser silhouettes. Dresses were often made from light, gauzy fabrics and were cinched under the bust. Hair was curled into elaborate updos.

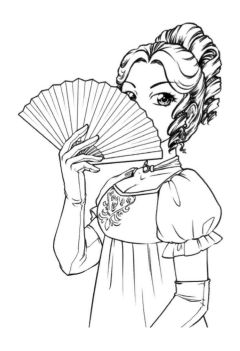

Etiquette meant everything in England. One had to be very careful with words and behavior, particularly in middle- and upper-class society. But there were secret ways to communicate with someone who had caught one's eye, such as by gesturing with a fan!

TRADITIONAL JAPANESE CLOTHING

We can't ignore the country where manga was born! Japan has an amazing history, and its people still wear its beautiful traditional clothing, particularly during ceremonies, competitions, and festivals.

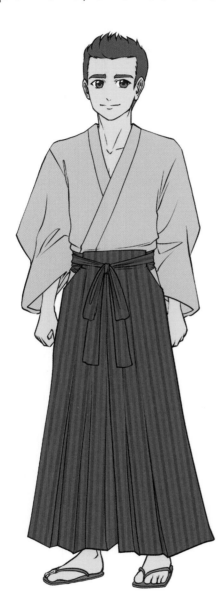

This two-piece outfit consists of a short top and pleated pants called "hakama." Both men and women have worn hakama for centuries. Nowadays hakama are most commonly used in martial arts. They come in different colors and patterns and can be tied in different ways. This character wears "zori" sandals made from woven straw.

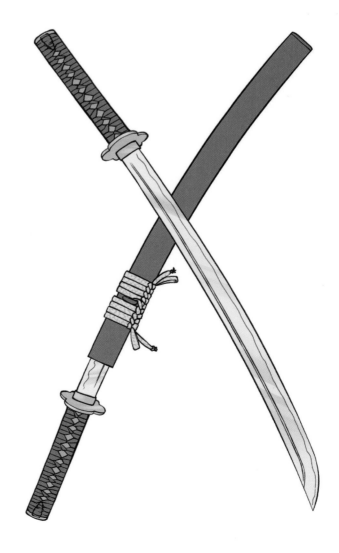

Whether you are creating a samurai drama or a modern action thriller, you should know about Japan's beautiful and deadly sword: the "katana." These can come in different lengths, curves, and blade patterns, but the one here is the most common. The sheath is smooth with a hook near the top and lacing that can be tied to a belt.

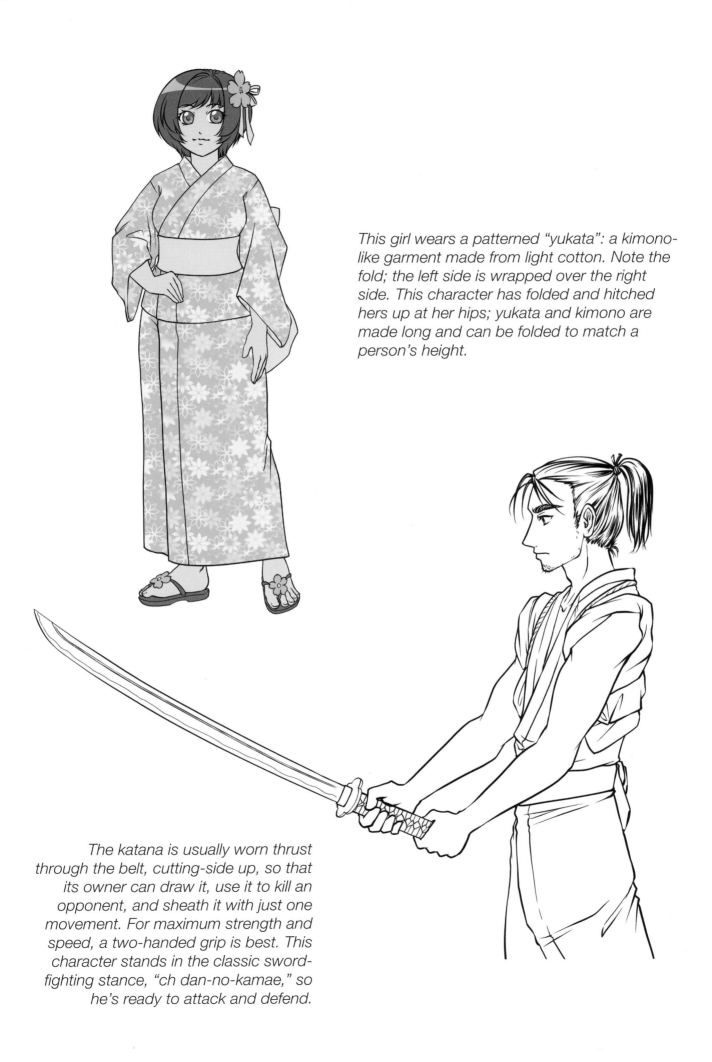

This girl wears a patterned "yukata": a kimono-like garment made from light cotton. Note the fold; the left side is wrapped over the right side. This character has folded and hitched hers up at her hips; yukata and kimono are made long and can be folded to match a person's height.

The katana is usually worn thrust through the belt, cutting-side up, so that its owner can draw it, use it to kill an opponent, and sheath it with just one movement. For maximum strength and speed, a two-handed grip is best. This character stands in the classic sword-fighting stance, "ch dan-no-kamae," so he's ready to attack and defend.

FANTASY CHARACTERS

Fantasy is a very popular theme in manga. With manga, you can enter a completely imaginary world! Whatever you choose to draw, you still need to make sure everything works practically. How does a character sheath his sword? Does he use magic?

WARRIORS

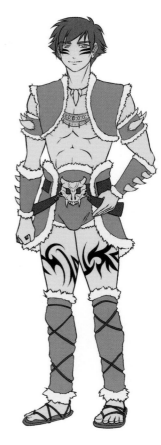

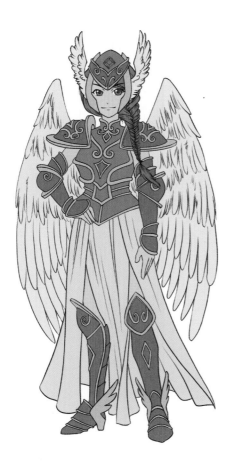

This barbarian warrior has a primitive look. His accessories are made from beasts he's killed, and he has tattoos and face markings.

This warrior maiden is inspired by the fierce Valkyries from Norse mythology. The young woman might have died valiantly during a battle and returns as an avenging angel to lead her army to victory in the final battle at the end of the world.

Fantasy stories wouldn't be the same without monsters and magical beasts! Let your imagination run wild. Dragons, unicorns, firebirds, sphinxes, and chimeras are great starting points.

MAGIC CASTERS

The characters who can cast spells, curses, hexes, and charms have many names: witches, warlocks, wizards, magicians, sorcerers, mages, and more. These characters do not rely on physical combat, so they are often dressed in longer robes and cultivate a hint of mysticism in their clothing.

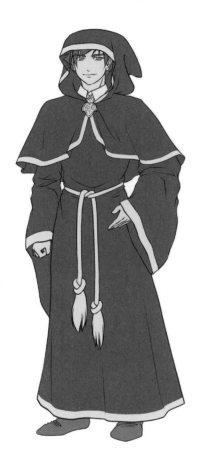

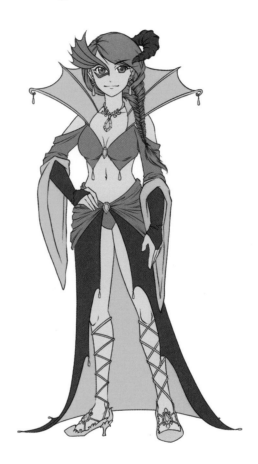

This wizard wears a long, dark robe, and his sleeves flare and billow when he casts a powerful spell. For real-life inspiration, consider priests' and monks' robes.

This sorceress is alluring as well as intimidating! Her elaborate, delicate outfit demonstrates her status and power, although it's completely impractical for combat. She doesn't concern herself with that. Her spells can incapacitate anyone!

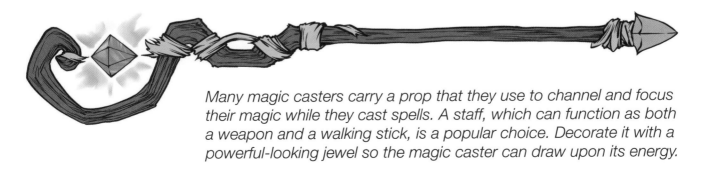

Many magic casters carry a prop that they use to channel and focus their magic while they cast spells. A staff, which can function as both a weapon and a walking stick, is a popular choice. Decorate it with a powerful-looking jewel so the magic caster can draw upon its energy.

FANTASY RACES

Whether they are mermaids, werewolves, vampires, pixies, or trolls, fantasy characters are usually humanoid (or at least part human) and feature different builds, skin colors, and extra limbs.

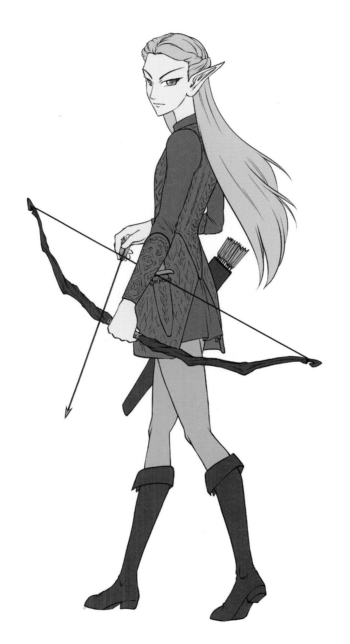

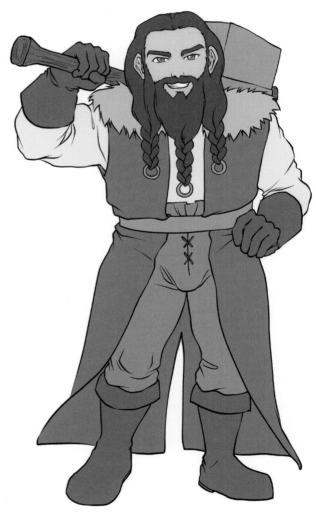

Elves are usually tall, slim, and ethereal-looking, with long hair and pointed ears. There are variations, such as high elves, who dwell in cities and palaces; wood elves, who disappear into forests; and dark elves, who live underground and command vicious beasts.

Dwarves are short and stocky. Hardy and hard-working. They are powerfully built and immensely strong for their stature. They are often portrayed living underground or in big cities. Facial hair is key; even the women often sport braided beards.

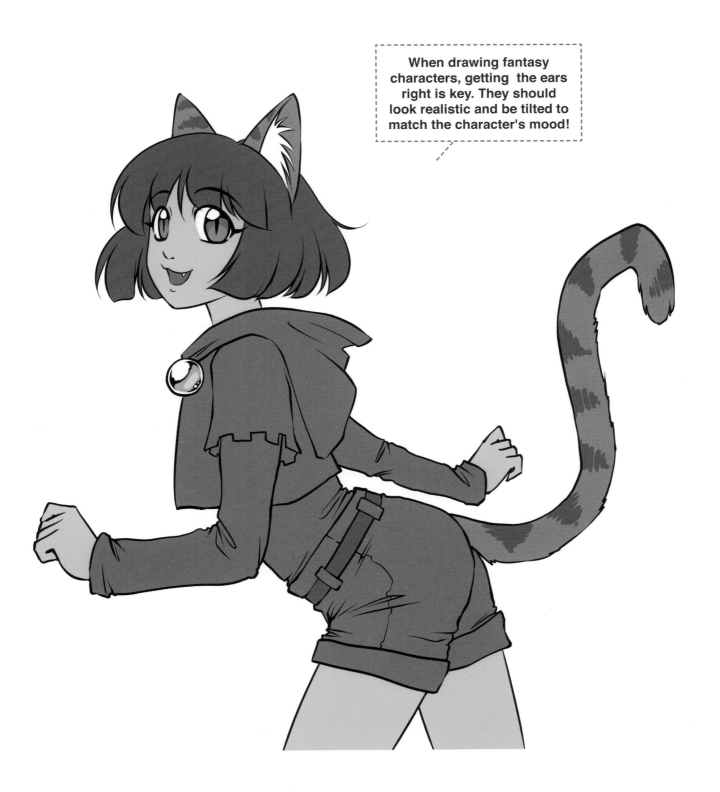

When drawing fantasy characters, getting the ears right is key. They should look realistic and be tilted to match the character's mood!

Extremely popular in manga and anime, "kemonomimi," or "animal ears," are characters that possess animal-like features. This character is a cat girl, or "nekomusume."

SCIENCE-FICTION CHARACTERS

When you draw a science-fiction character, remember to consider whether he, she, or it could be feasible in a futuristic world. Try looking at recent technological advances for ideas!

CASUAL WEAR

If you fast forward fashion by 10 or 20 years, what do you predict will change, and what will stay the same? The key indicators of technological advancements in clothing often lie in the fastenings and the fabric. Try to show this with form-fitting and architectural designs fastened with near-seamless zips and ultra-smooth buckles and tabs.

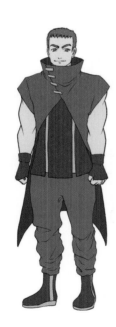

This man's outfit is loose, but it drapes dramatically. The seams give it a futuristic, cyberpunk feel, but the pants, gloves, and sleeves suggest an underground urban setting.

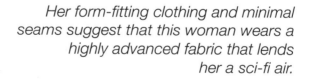

Her form-fitting clothing and minimal seams suggest that this woman wears a highly advanced fabric that lends her a sci-fi air.

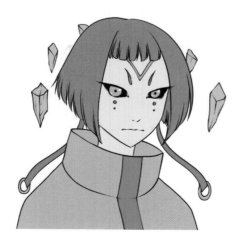

Many manga series feature aliens that resemble humans ... save for a few obvious differences. Try changing hair, skin, and eye colors when drawing an alien.

FORMAL WEAR

Many sci-fi stories have a militaristic feel. So when it comes to more formal clothing, characters might wear uniforms. But there are also very special occasions that require evening attire!

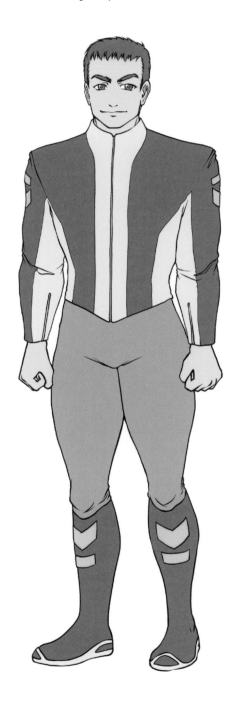

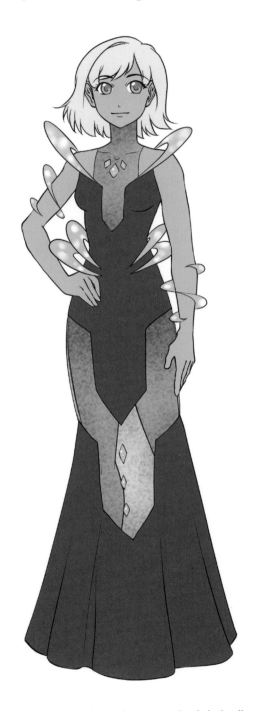

This character looks like he could be reporting for duty on a starship, attending a war council, or carrying out administrative orders. The perfectly fitted jacket, sleek neckline, and seams all look very modern, and the markings on the sleeves show his rank.

A high-society lady going to a lavish ball on a star cruiser needs to dress to impress! This gown is a wonder of textures and materials, with gravity-defying glittering discs swirling around her figure. The clean lines give it a futuristic feel.

BATTLE ARMOR

Now we get to the real stalwart of sci-fi character design. Your characters should look like combat soldiers, so do your research, and design something that looks more advanced than what special-forces troops wear today.

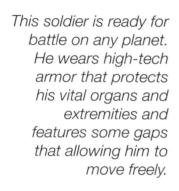

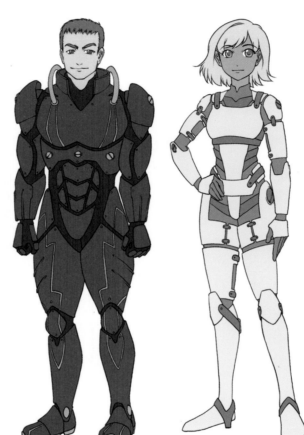

This soldier is ready for battle on any planet. He wears high-tech armor that protects his vital organs and extremities and features some gaps that allowing him to move freely.

This armor looks lightweight but functional; she can move easily and is well protected.

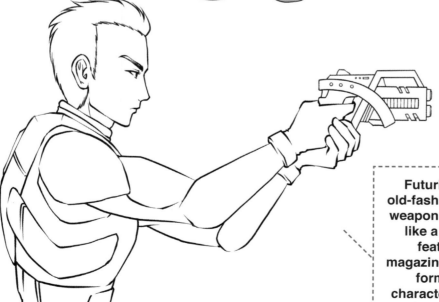

Futuristic weapons don't rely on old-fashioned bullets. Try designing a weapon that can be held comfortably like a conventional gun, but that features a different barrel or magazine to accommodate alternative forms of ammunition. If your character shoots a plasma pistol, he should hold it in a realistic way.

PRACTICE HERE!

Now it's your turn to let your imagination run wild! Try designing a sci-fi character. What if he's from an apocalyptic future where resources are scarce? Maybe she's the ruler of a distant planet covered in ice?

BRINGING IT ALL TOGETHER

Now that you've had a chance to think about all of the elements required to create a complete character, let's follow this case study of a character and her different stages of development before creating a final turnaround image.

INITIAL SKETCHES

Start with a few pencil sketches to get a feel for your character, her stature, how she moves, and what she would most likely wear. This character is a "kitsune," or a fox girl, hence her long, bushy, white-tipped tail. She's probably at home in a fantasy setting.

Foxes are known to be slinky and sly, so be sure to communicate this through your character's body language.

FACIAL EXPRESSIONS & PERSONALITY

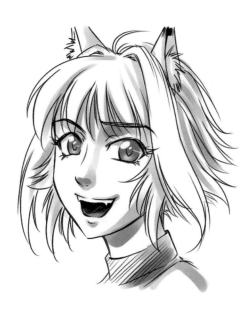

Try a few facial expressions on your character to explore how she would look if she were angry, sad, or embarrassed. Maybe she's quick to laugh, but bares her fangs when she's angry. Otherwise, she won't show many emotions, even when she's troubled.

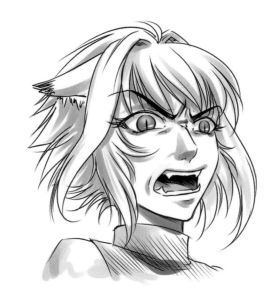

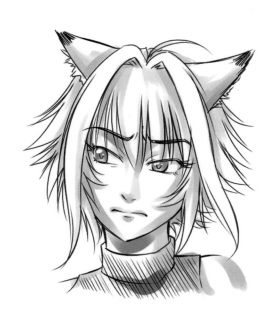

FINAL TURNAROUND

A turnaround shows the front, back, and side view of a character. Most manga and anime series require a turnaround for everyone to agree on an official design for a certain character. It also serves as a useful reference for an artist, particularly if he or she is drawing many characters or costume changes.

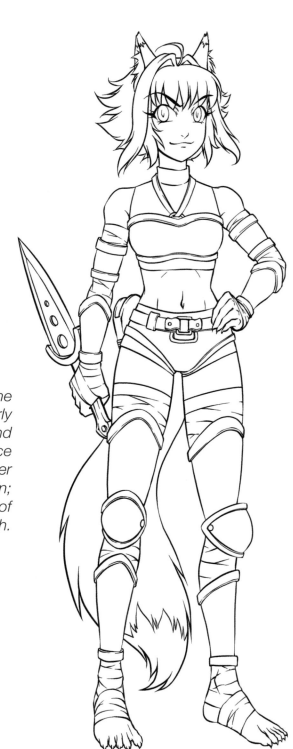

Start with a clean outline of your character, clearly showing her armor and how it's fastened. Notice that her armor never touches her bare skin; it's layered on top of bandages or cloth.

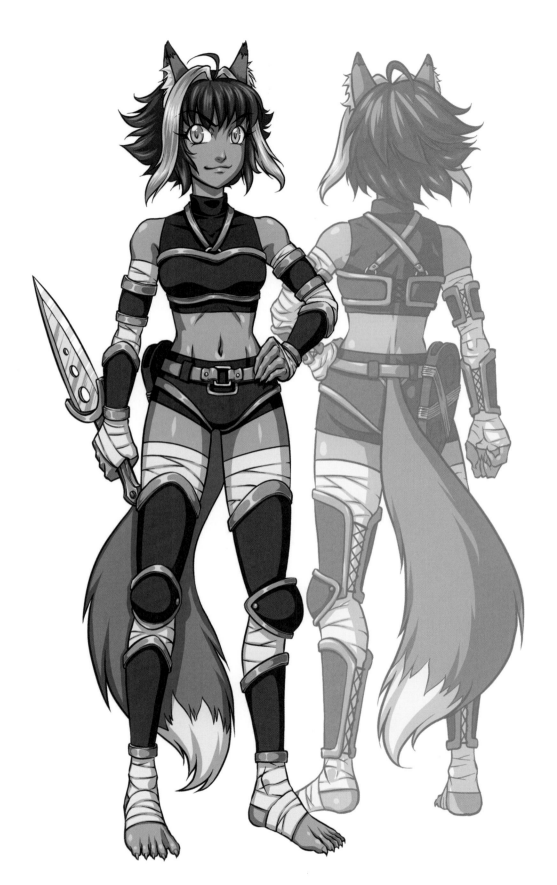

This colorized view shows her front and back. A crisp, clean coloring style is best for turnarounds, as it provides a clear reference for you to copy colors from in the future. Choose a color scheme that works with the setting and the character's personality, such as warm reds and browns for her animalistic traits and fiery nature. Now try creating your own turnaround on a separate sheet of paper!

BACKGROUNDS & SURROUNDINGS

Just like drawing people, creating backgrounds and surroundings for your manga stories requires familiarizing yourself with some simple principles to build correctly proportioned structures and environments.

VANISHING POINTS

It's one thing to learn about theory; it's something else to put it into practice and recognize how it applies to the world around you. Vanishing points are all about where things fade off into the distance. When you have a good eye for vanishing points, building up your backgrounds will become a lot easier.

CREATING DEPTH & SCALE

Using perspective correctly is the key factor to getting the scale of your images right.

ADDING DETAILS

Convincing backgrounds need authentic details that make contextual sense. Do your research, get the architecture right, decorate interiors with the appropriate props, and learn about the plants that suit your setting.

CONVEYING A LOT WITH VERY LITTLE

Manga doesn't always give you the room to create a large background shot, and drawing surroundings can be very time consuming. Usually you have to reinforce the scene's setting with just a small panel or a little space behind the characters. Master the art of interesting angles and definitive close-ups!

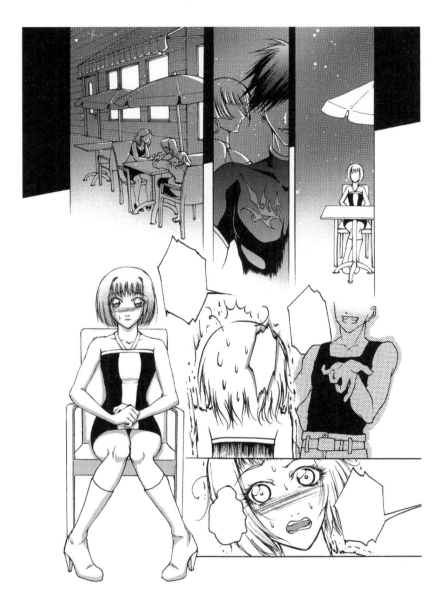

DON'T BE SCARED!

It's no good if your characters look beautiful and realistic but your backgrounds don't; that ruins your artwork and negates all of your hard work! Try to work a little bit of background into every page.

ATMOSPHERE & EFFECTS

How you shade and color a background can completely change its atmosphere. Consider how different a neighborhood looks when it's sunny versus stormy. Manga uses all sorts of special effects as visual metaphors to heighten the emotions of a scene.

ONE-POINT PERSPECTIVE

Drawing in one-point perspective is an easy way to create an impressive backdrop for your manga stories. All lines eventually lead to a point on the horizon, and parallel structures have corners and edges that consistently fall along these same lines, parallel to your point of view. These lines originate from a single vanishing point.

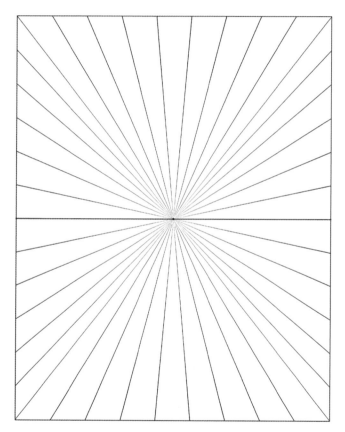

Along the horizon is a single vanishing point from which lines parallel to the viewing angle radiate.

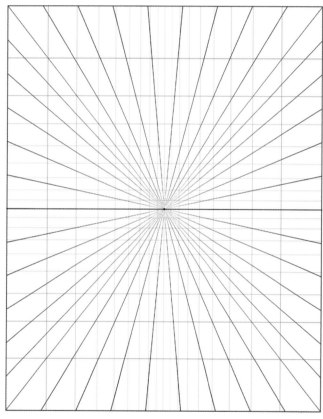

Laying horizontal and vertical lines on top helps you see how to begin placing 3D objects in this space.

Buildings are three-dimensional objects, and not all of their corners are parallel to the viewer's point of view. Vanishing point lines are horizontal and vertical, and they converge as they approach the vanishing point.

MAPPING & PLANNING

This step is optional, but it will help you visualize your scene and keep its elements consistent, especially if you need to draw the same city from a different angle later on. Start with a two-dimensional bird's-eye view of a city in a map layout. Lay the map on your vanishing point lines, matching it up to the edges of the roads and buildings. Then add volume!

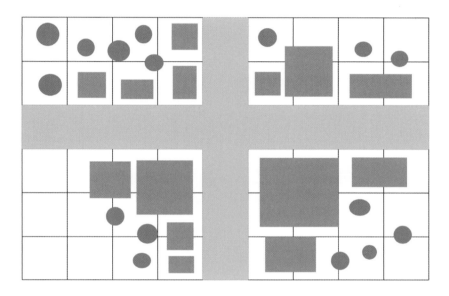

This flat plan of a city features roads, buildings, and trees.

One-point perspective works well for showing off street scenes and urban exteriors with lots of sharp-cornered buildings as well as for creating three-dimensional drawings.

Line up the edges of the buildings to match the vanishing point.

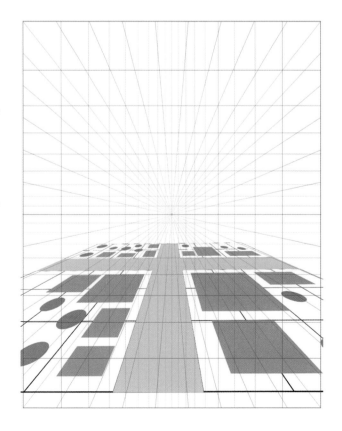

ADDING VOLUME

Using the vanishing point as well as horizontal and vertical lines, create your city scene by drawing boxes in perspective. Illustrate buildings of varying heights and sizes, and make sure the sides of the buildings remain visible to imply depth.

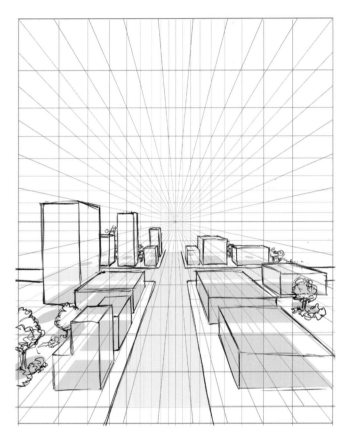

Building up from your map, draw simple boxes, and use the edges of the image to show off as many sides of the buildings as you can for increased depth.

Add more boxes until the city looks sufficiently busy, and then add the buildings' details on top of the rough shapes. Details like windows and doors make your city look real!

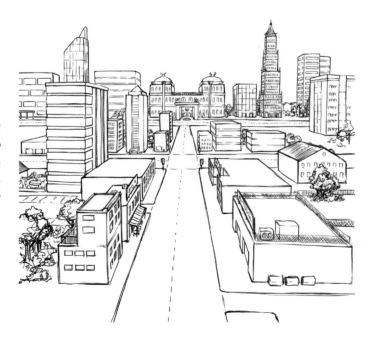

PRACTICE HERE!

Now try creating your own street scene. This guide features a vanishing point and lots of horizontal and vertical lines.

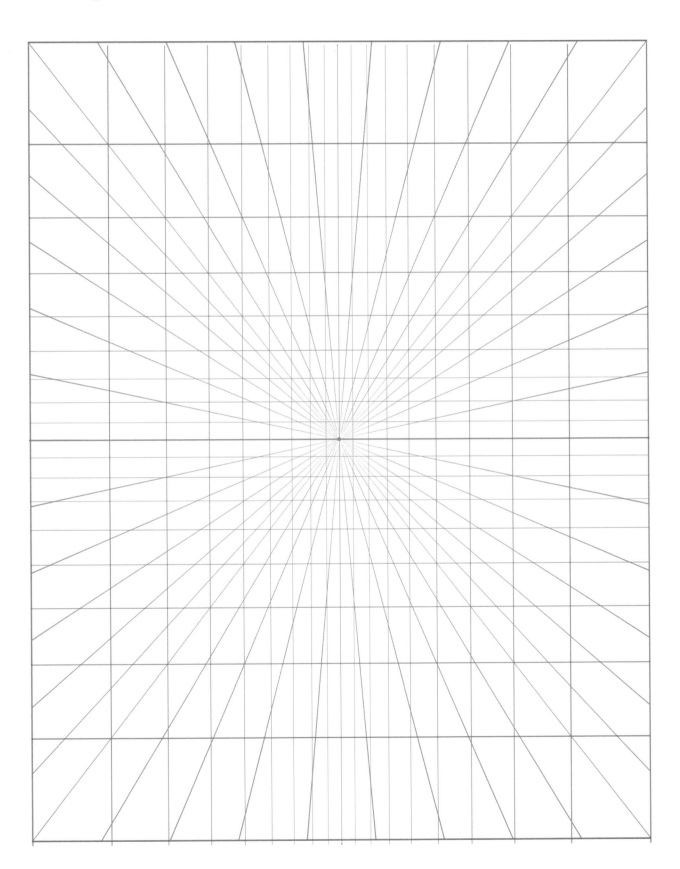

TWO-POINT PERSPECTIVE

This technique is not as simple as one-point perspective, but it makes more sense in most everyday environments. Imagine you are looking directly at the horizon using one-point perspective. Now picture yourself rotating slightly away from this point. Any shapes, buildings, lines, and corners that were previously perfectly aligned are now diagonal to you. Lines on the left-facing side of the object lead to a vanishing point on the left, and lines on the right-facing side of the object lead to another vanishing point on the right.

Along the horizon is a vanishing point on the left side of the image, from which lines parallel to any surface facing left, radiate.

In addition to the first vanishing point is another point. This time, it's on the right side of the image. Its radiating lines are parallel to right-facing surfaces.

DRAWING A BUILDING WITH VERTICAL LINES

The two vanishing points account for length and width, but 3D objects also need height. You can add vertical lines to build them up. Note that just as in the one-point perspective view, the lines should converge as they near the vanishing points.

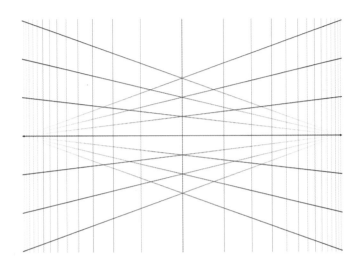

Use the three sets of vertical lines when roughing out the overall shapes of buildings and adding height to them.

Don't make buildings too wide as they get closer to the vanishing points; everything shrinks as it gets farther away.

Block out some basic boxes using the two vanishing points on the sides and vertical lines for height. If necessary, continue to add more radiating lines for any details and decorations on the buildings. Line up the windows, doors, and cornices. Use these radiating lines to help gauge height more realistically.

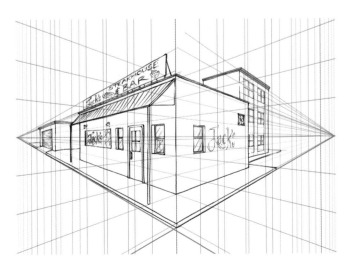

As you add details to your buildings, make sure any straight edges that are parallel to the ground line up perfectly with the radiating lines from the left or right vanishing point, depending on whether it is on a left-facing or right-facing wall.

ILLUSTRATING INTERIORS WITH TWO-POINT PERSPECTIVE

You can also use two-point perspective to draw interiors. Imagine that you are drawing the inside of a shoebox. The theory works in reverse: The far-left wall faces right, so any lines on this wall will lead to the vanishing point on the right, and vice versa.

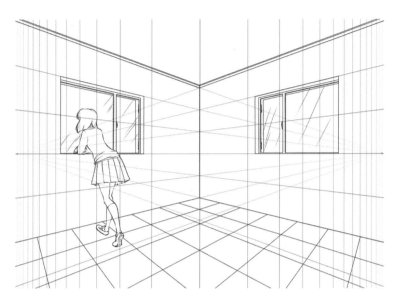

This room doesn't contain any furniture, but the tiled floor and the windows ground the scene, and the girl looking out the window shows the scale.

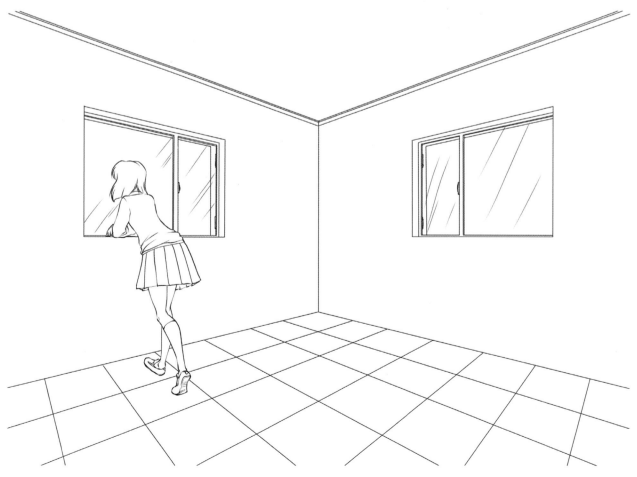

PRACTICE HERE!

Now try drawing the interior of the apartment. First draw it unfurnished, and then add details, such as curtains and a sofa.

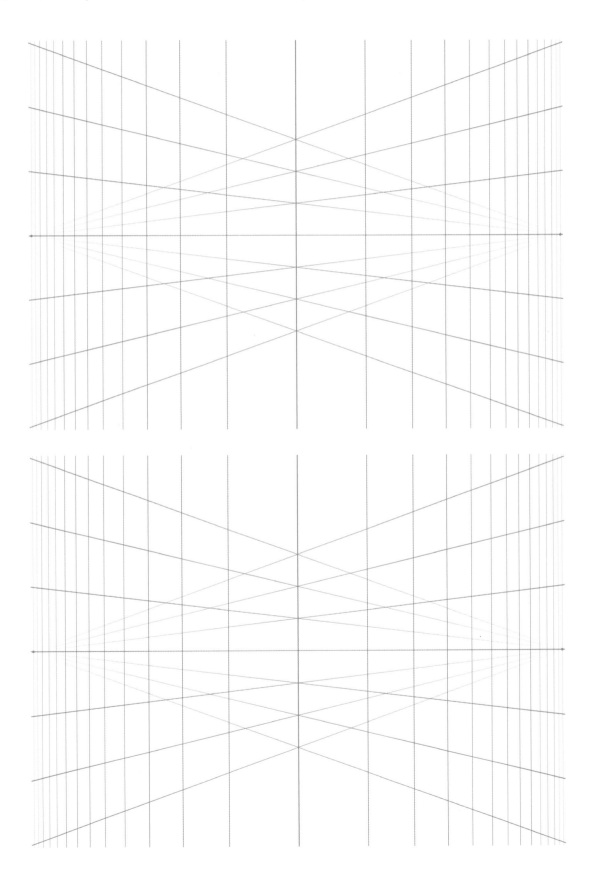

EXTENDING TO EXTERIORS

Now that you know how to draw buildings using perspective, here are some examples that will help you add details and atmosphere to your structures' exteriors.

WINDOWS

Windows add depth and perspective to a drawing. Pick a style that suits the age, location, and purpose of the building.

Start by drawing some basic shapes. Then add details. Shading and white streaks on the panes imply that they're made of glass.

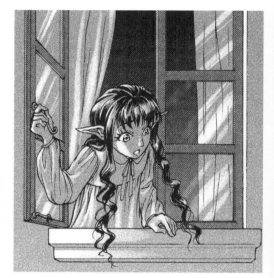

This is a traditional-looking window, so it makes sense that the character peeking her head out of it wears an old-fashioned nightgown.

DOORS & GATES

Consider the style of your doors and gates to ensure that they suit their setting and the use of the building. External doors are strong and sturdy, many modern doors have a window, and gates are usually made of wood or metal.

STYLING BUILDINGS

Think about the design and shape of the building you are drawing. Is it a country cottage with a low, peaked, thatched roof? Maybe it's a glass-fronted skyscraper! Look at the following examples, and consider which elements work well together.

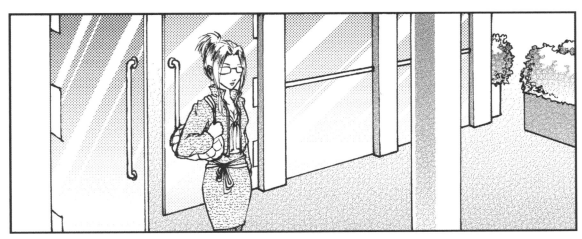

The clean, straight lines indicate that this is a commercial building, possibly for business or shopping.

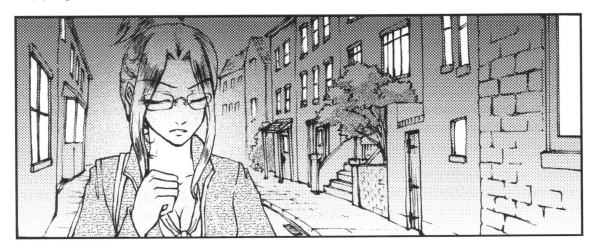

As the character continues her journey, you can see that she is now walking through a residential neighborhood.

When drawing a city from a distance, a nighttime silhouette of the tall skyscrapers looks impressive. Try to add a glow to the overall lighting, and draw lots of bright windows.

DIFFERENT ANGLES & VIEWPOINTS

You don't have to draw entire buildings or use a typical camera angle in manga. Often you will see medium shots and close-ups of a character, which don't leave much room for the background. Use diagonals and upward angles to hint at the background.

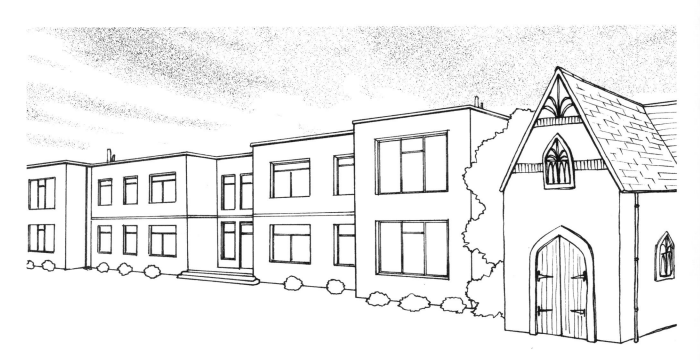

This could be a school building, with flat-roofed square blocks serving as a newer addition to what was an old schoolhouse with wooden doors and a peaked roof.

This is the same location, but now you see just a small upward shot of the old and the new building.

PRACTICE HERE!

Now try designing a building's exterior. Decide what the building is used for and where it's located. Why not try drawing a futuristic school? How about a fantasy café?

DRAWING BUILDINGS' INTERIORS

Many manga scenes take place indoors. On page 106, you learned how to draw interiors using two-point perspective; now you need to make sure that a room's ceilings and corners are represented correctly along with all of the other touches that make an interior believable.

WINDOWS

When drawing a window from the inside, create hinges, locks, shutters, handles, and locks as they are seen from within. The most important things to get right are the soft furnishings that cover the windows: curtains and rods, blinds, and so on.

 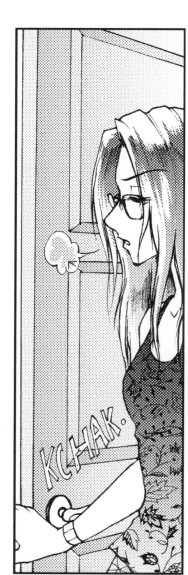

Here are some windows as seen from the inside. Notice how the window is set deep within a recess to account for the thickness of the exterior wall. You can also add curtains or blinds to the windows.

INTERIOR DOORS

Doors can range from very plain to very elaborate. Try adding beveled panes!

Here you see a character pushing open a door. The picture is a small panel. Making the door handle and beveled paneling visible lets the reader know that it's a door, probably inside a home.

FURNITURE

Buildings are filled with furniture! Keep in mind that the furniture must suit the room's purpose, whether it's a bedroom, a busy office, or a cafeteria. If the pieces of furniture have straight edges and are lined up with the walls, their corners have to follow basic perspective and vanishing points too. Remember to keep things consistent, and make sure the furniture is positioned correctly even if the viewpoint changes.

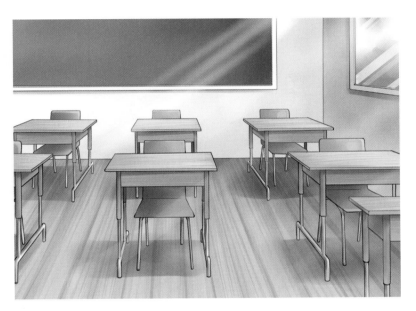

The blackboard and individual tables lined up with chairs neatly tucked under indicate that this is a classroom. The edges must match the one-point perspective from the center of the image.

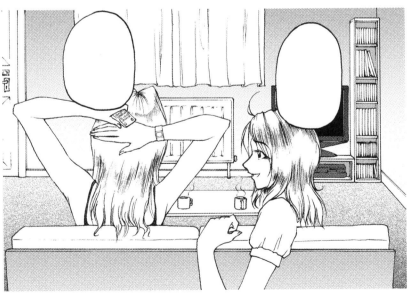

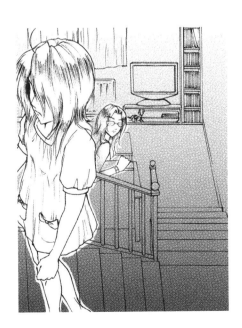

The first picture shows the interior of a home with two young characters in it. What could they be talking about? This next panel is from the same manga but a few pages later, as one of the characters heads upstairs. Note how the furniture items are still positioned the same way, even when seen from a different angle.

OTHER DECORATIONS

There are various ways to decorate an interior and give it atmosphere. You can include rugs, put wallpaper on the walls, and perhaps add wood paneling. Just as in real life, many buildings in manga stories have paintings or tapestries on the walls. Some buildings feature columns or ceiling plasterwork.

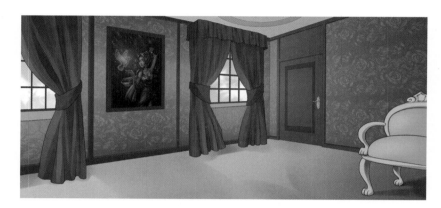

This ballroom's damask wallpaper, plush curtains, claw-footed sofa, and large painting make it look quite fancy. Observe the lighting conditions; during the day, the windows bring in soft lighting.

This fantasy example shows two characters eating breakfast in a pub or diner. The wood paneling gives it a cozy atmosphere, as do the small paintings and needlework on the walls. The windows demonstrate the pub's age.

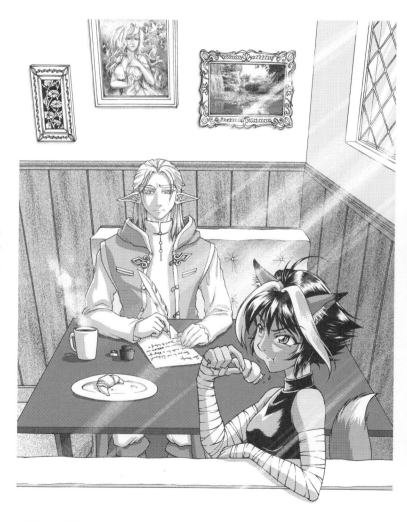

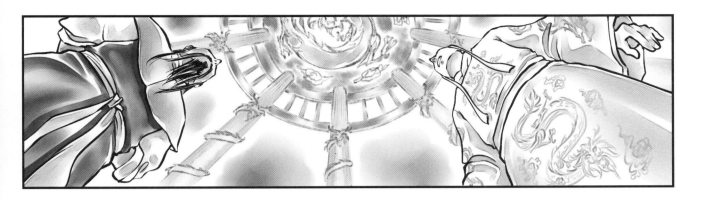

Look at this dramatic upward camera shot of two characters in a confrontation in an opulent Chinese palace. The columns give it depth, and the huge painting on the ceiling looks extravagant.

PRACTICE HERE!

Try drawing your own bedroom. This exercise will help you understand and analyze all of the things you need to include in a realistic manga. Your manga characters might have a similar bedroom!

FORESTS & GREENERY

Manga stories take place in many environments, including forests, parks, meadows, and countryside. Learning how to accurately and efficiently recreate flora will make the natural environments in your manga stories look much more believable.

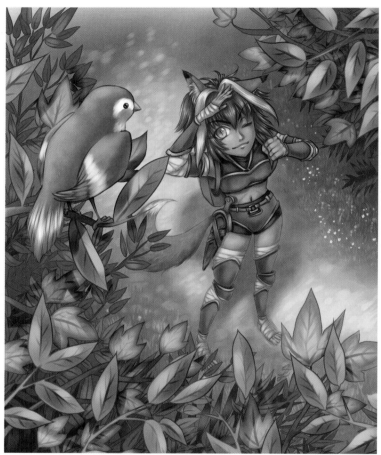

This image looks down through the forest canopy to the character below, putting different layers of leaves and branches into focus. Compare the leaves' shapes and how they sprout from the branches.

When drawing trees, start with basic shapes before adding details and texture. First draw the trunk and a puff of leaves at the top, and then refine the branches and roots into more realistic shapes. Group clumps of leaves in front and add leaf textures behind, making the bark look scratchy.

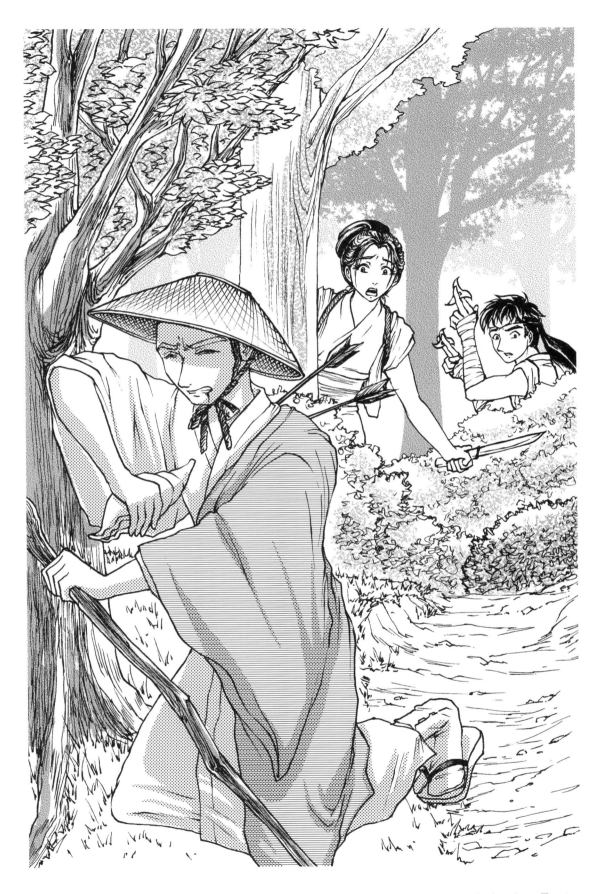

When drawing a forest scene, add a mixture of trees, grasses, and shrubs. Feature different species, and show depth by layering them and making their outlines hazier as the distance from them increases. In this picture, notice how the trees in the distance are defined as shadows without distinct outlines.

ROCKS & CAVES

Natural stone, exposed cliffs, caverns, and mountain peaks all have very different textures. Decide on the overall shape of the rock or cliff, and then define how smooth or faceted you want it to be before adding shading to highlight its texture.

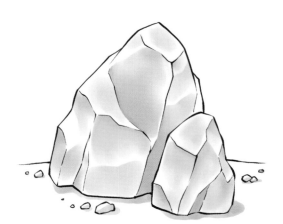

Create a mixture of smooth and hard edges to give rocks an organic feel. Use lines to define a boulder's multiple faces and sides. When adding shading, think about the light source. These boulders are lit from above and slightly left, so upward-facing facets will look lighter.

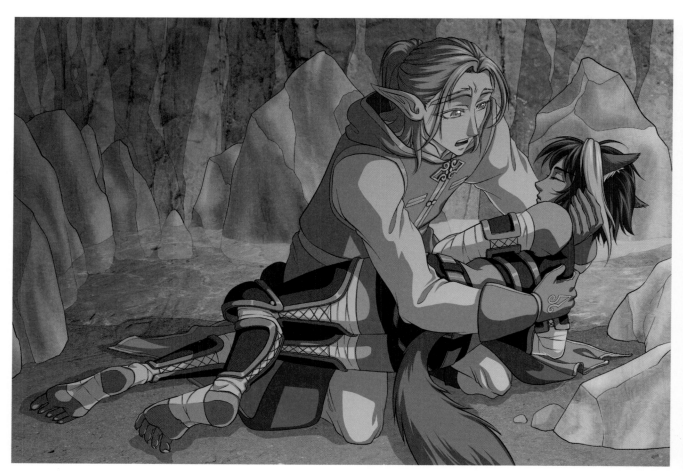

Some caves are formed naturally; others have been carved out by miners or inhabitants. When drawing a cave, aim for a dim glow or a flickering light. Notice this cave's large boulders rising from the lake and its dim, indistinct lighting.

This cave looks man-made, with its clearly defined walls and ceilings and wooden columns. The lighting, which comes from a flaming torch, is harsh and creates strong contrasts between highlights and shadows.

MOUNTAINS & CLIFFS

Mountains are exposed to the elements, and most of their jagged edges look smooth from a great distance. The main thing to focus on when drawing mountains is creating a sense of depth. Use thinner line weights, and fade them out as the distance increases.

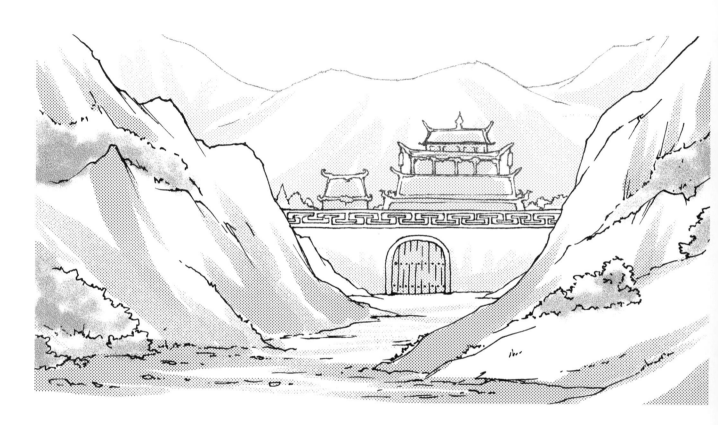

Shading and fading adds to the feeling of depth in these mountains. Here, an ancient temple is hidden in a valley. The bases of the foremost mountains are close, so they are clearly defined with sharp edges and shrubbery. The mountains behind the temple are much farther away, so they look smoother and less distinct.

PRACTICE HERE!

Try drawing two different types of boulders: one that is very smooth and one that is sharp and jagged. Use a pencil to shade, and think about the differences between the two.

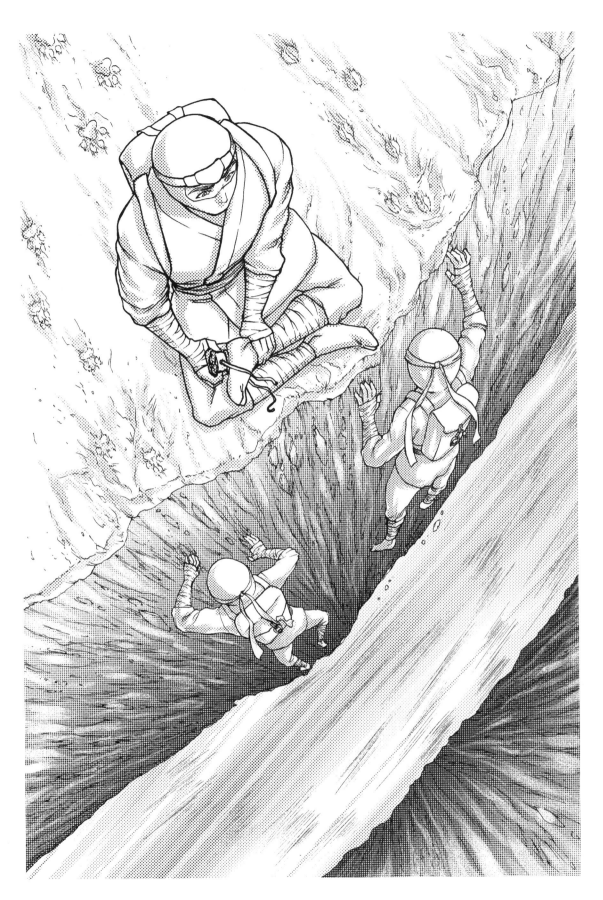

This dramatic shot of ninjas climbing down the side of a ravine with a fast-flowing river far below has a dizzying sense of vertigo. Notice the lines on the cliff face that lead to a single vanishing point.

BODIES OF WATER

Let's start with relatively still bodies of water like ponds and sheltered lakes. You will generally use blue and greens to render these because they reflect the sky above or the green hues of the surrounding forest.

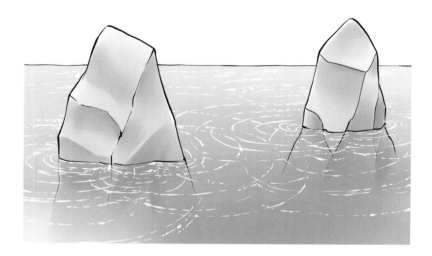

Start with gradients and washes to create a sense of the overall lighting, and then add bright highlights along small waves and ripples.

The ocean shows much more movement even when relatively calm. Stormy waves become larger, crashing into anything that gets in their way. Start with gradients, and add highlights and shadows to define the waves.

Underwater scenes can provide wonderful settings for fantastical manga characters like mermaids. Start with a gradient that's dark at the top and becomes lighter as the water deepens. Add highlights and weak rays of diffused light to the surface of the water.

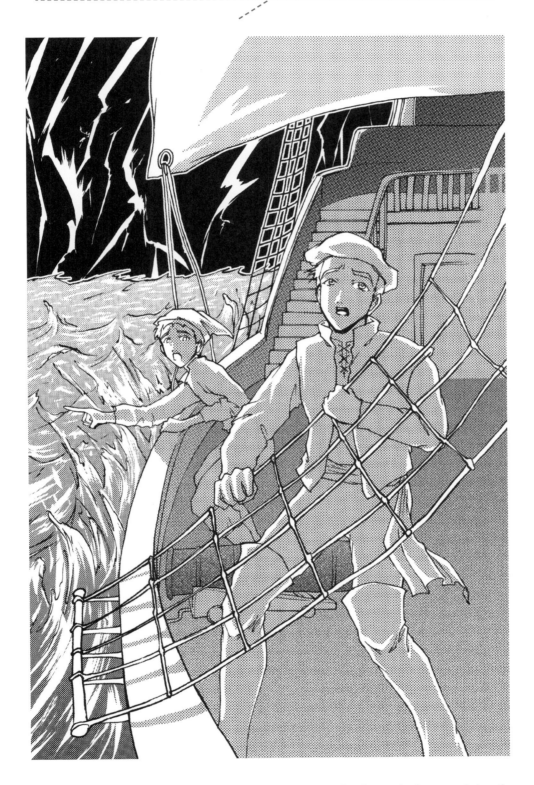

When a ship is caught in a storm, the waves froth and churn, violently crashing into the sides of the boat. Outline a few large waves, lay down a base gradient, and then add white highlights throughout, particularly along the edges of the waves.

SPECIAL EFFECTS

Now try enhancing your manga illustrations with special effects! Action scenes aren't complete without explosions and smoke.

SMOKE & CLOUDS

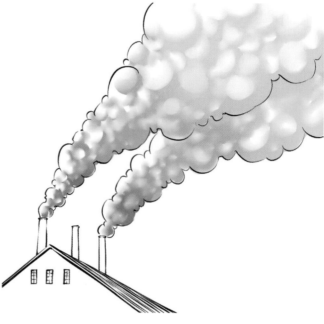

For wispy, up-close smoke, use thin lines, and hint at the smoke trails. When you add color, you can vary your wispy tendrils from fully opaque to transparent as they dissipate.

Thick, billowing, distant smoke looks opaque and cottonlike, breaking up only as it moves away from its source. Shade the undersides of the smoke puffs.

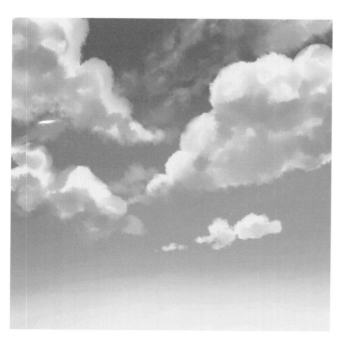

Clouds take different shapes at different heights in the atmosphere, so layer them, and vary their sizes. Start with a gradient for the sky, and then rough out the cloud shapes. Soften the edges as needed, particularly for wispier clouds. Shade the undersides to give the clouds depth.

FIRE, EXPLOSIONS & LIGHTNING

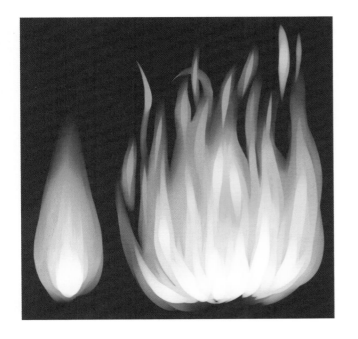

Fire looks best against a dark background. Use dull yellow, orange, and red for the flames, with bright yellow and slashes of white in the center to indicate extreme heat. Notice the shape of a single flame versus that of a large fire.

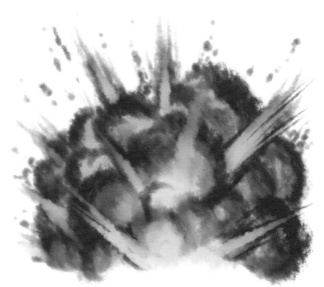

To draw an explosion, start with dark, thick smoke that radiates from the center. The outer edge of each puff is darker. Finish with a few bursts between the smoke puffs radiating from the center with extra dirt and debris. If adding color, hint at flames using yellows and oranges.

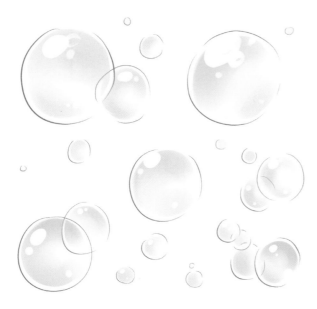

Bubbles require a light touch. Use thin outlines with plenty of gaps and highlights.

TELLING A STORY

Manga artists usually write their own stories. Here are some suggestions as well as pitfalls to avoid when writing your manga stories!

START SMALL

Create a short story that's eight, twelve, or sixteen pages long. Multiples of four work well. Legal-sized sheets of paper can be folded in half and stapled in the middle to create a booklet.

IDENTIFY YOUR MESSAGE

A manga story featuring one main message will feel cohesive and strong. The plot could encourage readers to take responsibility for their actions, or it could be about an apocalyptic future. It's up to you!

CHOOSING THE CHARACTERS & SETTING

Many writers love inventing original characters, but characters and a setting alone don't make a story. If they don't do anything interesting, nobody will want to read about them. Use them as vehicles for your message.

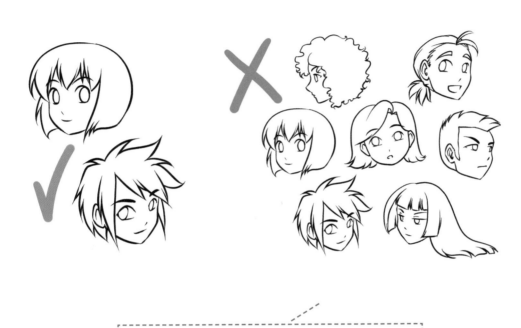

There isn't enough room in a short manga to effectively portray many different strong characters, so focus on just a few.

SELECT A BEGINNING, A MIDDLE & AN END

Keep a clear picture in your mind of the linear progression of your story. What causes the primary source of conflict? What happens when the main action starts? How does the situation resolve itself?

Whether you choose to showcase your story in a linear order is up to you. Hook your readers from the very start, and make the setting and message clear.

PRACTICE HERE!

Now it's your turn! Use this handy exercise to create a short story.

- **WHAT'S YOUR MESSAGE?**

- **WHO ARE YOUR CHARACTERS? CAN YOU DESCRIBE THEM?**

- **WHERE IS THIS STORY SET?**

- **IN LINEAR TERMS, DESCRIBE WHAT HAPPENS AT:**

- **THE BEGINNING**

- **THE MIDDLE**

- **THE END**

SCRIPTING FOR COMICS

Manga is a sequential art form and a visual medium, so it needs to be written in a format that can easily be converted into visual shots and scenes. Most comics are written as film scripts, with notes for panel sizing and page turns. Here's how to convert a rough idea into prose and script format.

DESCRIBE THE SCENE AS IT HAPPENS

Consider this the "free-writing" stage of drafting your story. It's perfectly fine to use short sentences that simply say "this happens" and "that happens."

A girl wearing a school uniform is sketching in her notebook during math class. The teacher calls on her to solve a complicated math problem on the board, but she doesn't hear him. He yells, so she covers up her drawing. Then she barely glances at the board and immediately solves the problem, to the admiration of the other students.

COMIC SCRIPTWRITING

It's just like writing a film script, complete with camera angles, zoom, dialogue, and characters' actions and emotions. Comic scriptwriting features a couple of additional complications, though; unlike movies or television shows, the size and shape of each panel on the page can change, and this must be included in the descriptions.

SCRIPT FORMAT

Page 1

Panel 1
(Exterior shot of the school's clock tower.)

Panel 2
(Interior midshot of a classroom full of students sitting at their desks as sunlight streams in. The focus is on Mercedes, who holds a pencil in her hand.)

Panel 3
(Close-up shot from Mercedes' point of view. She's sketching a Japanese rock star in her notebook.)

Teacher:
Class, how do we differentiate this formula? Why don't you try, Mercedes?

Panel 4
(Camera zooms out to a midshot of Mercedes, who continues to sketch in her notebook.)

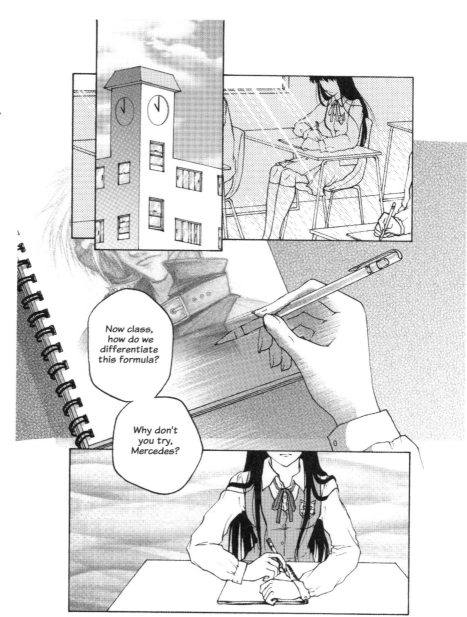

Now class, how do we differentiate this formula?

Why don't you try, Mercedes?

Page 2

Panel 1
(Large panel, medium close-up
of Mercedes looking startled.)

Teacher:
Mercedes? Are you even
listening? Ahem! MERCEDES
WHITING! Please pay
attention!

Panel 2
(Small cut-in of Mercedes'
hands covering her sketch.)

Panel 3
(Small shot over Mercedes'
shoulder as she looks at the
teacher and the whiteboard
with the formula written
on it.)

Panel 4
(Large panel, side-on-wide shot of Mercedes replying as other
students look on in the background.)

Mercedes:
d/dx f(x) equals 2 + 1/2x≤

Other students murmuring:
Wow!
That was so fast!
Amazing!
She didn't even need to work it out on paper!

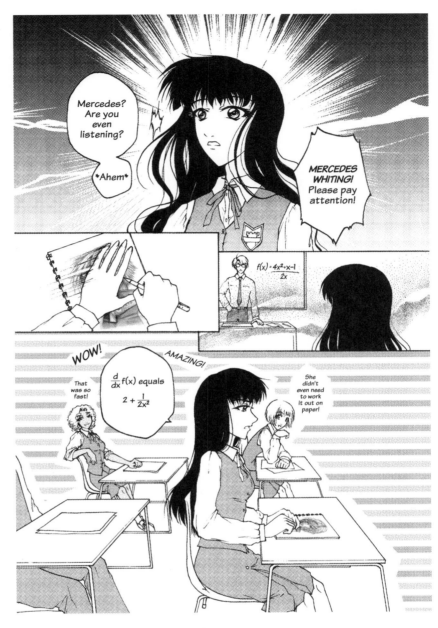

PAGE LAYOUT & DESIGN ELEMENTS

Manga features a very intuitive, organic flow of panels. Your goal should be to ensure that the panel order is immediately obvious without the use of arrows or number, and to make each panel suit its images in pacing and importance.

READING DIRECTION & PANEL ORDER

You can draw your manga from right to left, like the Japanese do, or left to right. In general, you should draw your comic in the direction of the language you wish to publish in. Arrange your panels so that they read and flow from one corner diagonally down to the opposite corner.

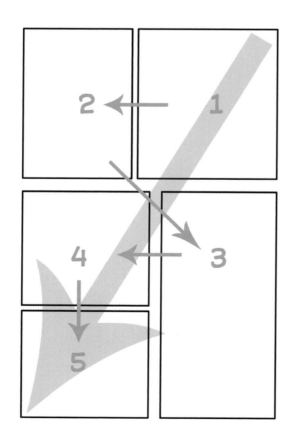

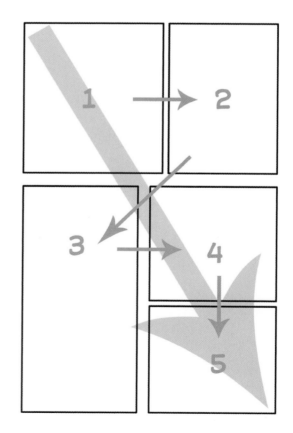

This page is laid out as the Japanese would read it. Follow the arrows and numbers to see how it flows from the top right to the bottom left.

This page is the mirror image of the first; it is appropriate to the English reading direction. Start in the top left, and then move across, moving down and across again until you reach the bottom-right corner.

GROUPING PANELS

Manga panels don't always follow the same format. The most important thing is to provide visual cues to the reader so that it's obvious when to move from a group of panels to the next column or row. There are two effective ways of grouping panels: changing the width of the gaps between the panels and misaligning them to separate one group from another.

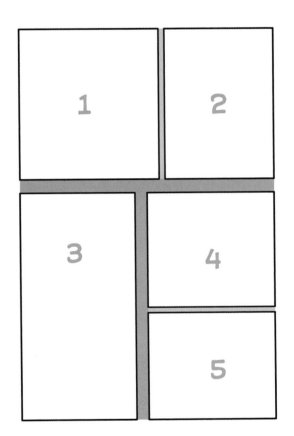

Panel gutters are the spaces between the panels. Keep the gutters within a group very thin, and thicken the ones outside a group.

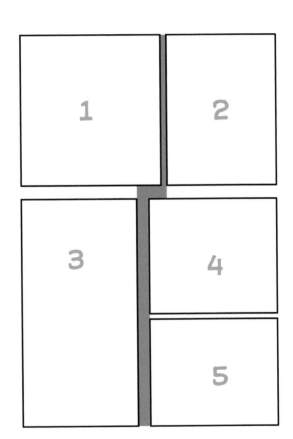

By misaligning the panel gutters, you can create a clear separation between groups.

Panels can come in many sizes and shapes, especially in manga.

Size: *The bigger the panel, the longer the reader spends looking at it, which slows the pace and gives the panel more importance.*

Shape: *Thin, narrow panels or spiky, diagonal shapes are great for fast-paced actions in quick succession.*

Overlapping panels: *Try overlapping two panels to show that things are happening very quickly.*

SPEECH BUBBLES

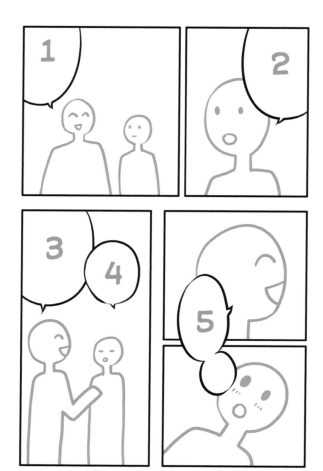

Speech bubbles also have to be positioned from the top corner to the bottom-opposite corner of every panel. Ideally they'll go across several panels too, so it's obvious how to read them.

Manga speech bubbles look rounder, taller, and bigger when compared with Western comics. They can have short tails leading back to the speaker, or they might not have tails at all.

A standard speech bubble looks like a thin circle or an oval. Spiky, irregular, hand-drawn outlines indicate raised voices. Illustrative effects like flames add mystique to a voice. Thoughts are given a soft outline with hazy lines or dot tones.

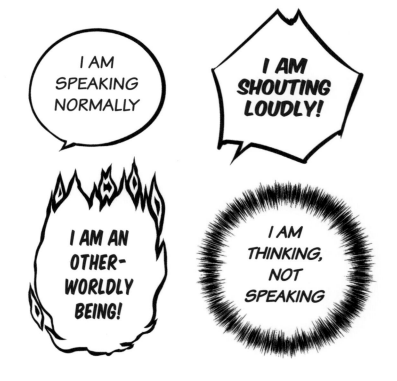

PRACTICE HERE!

Try drawing some characters and placing speech bubbles on these panels! What are your characters doing?

CREATING A MANGA PAGE FROM START TO FINISH

Now let's combine everything you've learned and create a final manga product! We'll focus on one page of a short story about fencing.

THINK OF A STORY

Feeling pressured by his parents and his fans, a talented young fencer named Kieran loses his passion for the sport. His coach, Imogen, remembers that it was his love of Alexandre Dumas' "The Three Musketeers" that got Kieran into fencing in the first place, so she encourages him to be silly and pretend he is his favorite character, D'Artagnan. He wins!

Flash-forward to a few years later, and Kieran is about to compete in the Summer Olympic Games. Once again, Imogen reminds him to relax and be silly, and he strides off with confidence.

SCRIPTING

We're going to focus on Kieran just as he's about to compete in the Olympics.

Panel 1
(Midshot of young Kieran in his fencing gear.)

Loudspeaker announcement:
And now, fencing for the United States: Kieran Knight!

Panel 2
(Camera pans out to a long shot. Kieran stands on the raised fencing strip and waves to the cheering crowd. The Olympic rings are visible on the wall behind him.)

Panel 3
(Close-up as Kieran looks over his shoulder at the coach's enclosure behind him. Imogen is waving to get his attention.)

Panel 4
(Midshot of Imogen shouting.)
Don't forget to be silly!

Panel 5
(Close-up of Kieran throwing Imogen a winning smile.)

CHARACTER DESIGN

Before drawing your story, make sure you have a general idea of what your characters look like.

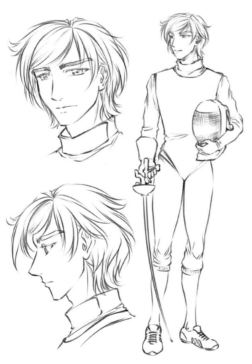

Kieran looks like a fencer: lean and light. He has a serious demeanor, but he can still enjoy himself!

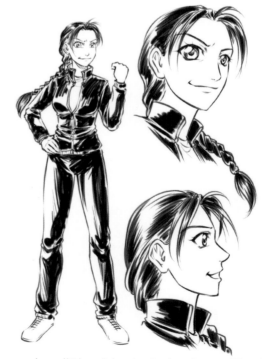

Imogen is a little older but also lean. She has a mischievous streak and an irrepressible sense of humor, even under pressure.

STORYBOARDING

Now, using your script, choose a page layout that works well with the story. Draw a very rough sketch of the characters before drawing the page at full size.

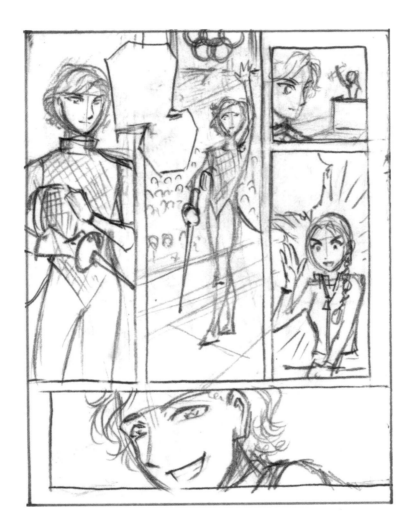

This thumbnail shows what the page will look like when laid out. Draw it in a small size so it's quick and easy to edit.

ROUGH DRAFT

Now draw your panels at actual size on your final sheet of paper, and block out the characters and speech bubbles using the storyboard thumbnails.

PANELS

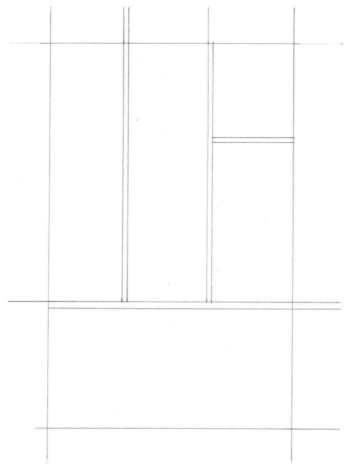

Draw the panels a generous distance from the edge in case the printer cuts off anything (allow for about ⅛ inch). Frames should match up with the safety margins.

Add your figures to the panels, keeping the characters' faces inside the safety margins.

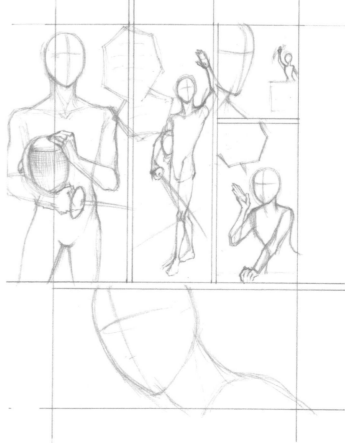

DETAILED PENCIL DRAWINGS

Do detailed drawings of the characters' faces, expressions, hair, and clothing. Draw the backgrounds too!

INKING

Now it's time to break out the pens! If you're nervous about making a mistake, try scanning your pencil drawings so that you have a backup, or scan and print your pencil drawings in a bright color, and ink over them.

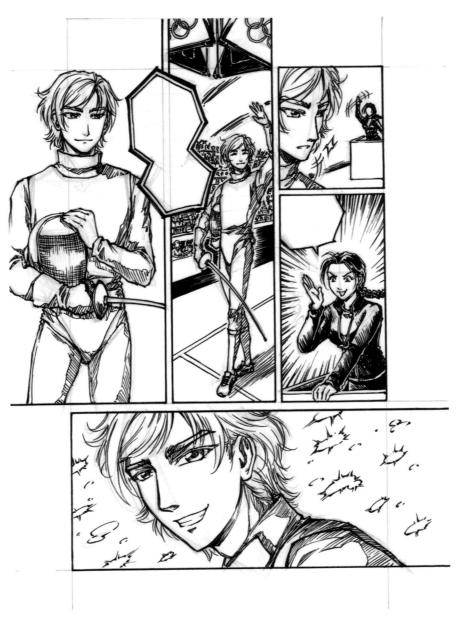

This manga is inked in a rough-and-ready style to match its action theme and young target audience.

REMOVING PENCILS

Many artists use a regular pencil (see page 6), enabling them to erase the marks. If you use a non-repro pencil, you can photocopy it or scan and filter out the colors digitally, which is often much quicker and cleaner. The page should look black and white.

LETTERING

Western comics often do this last, but manga speech bubbles and sound effects are almost entirely hand-drawn, so it makes sense to add letters before shading. That way you won't have to make more revisions later!

SHADING

Manga is usually done in black and white or gray scale, but that doesn't mean it has to look boring! There are different ways to add depth without color, including screentone. Traditional screentone sheets are large, clear, adhesive sheets that feature different patterns. To use, cut a piece from the adhesive sheet, stick it on your inked art, and cut away the excess.

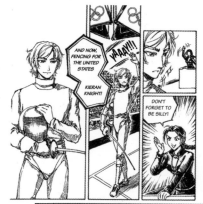

Here is the cleaned-up page with lettering. It's now ready for shading.

Some hatched and crosshatched shading was added during the inking stage, but some elements still needed screentone, such as the lamé jacket Kieran wears and the sparkly effects in the background.

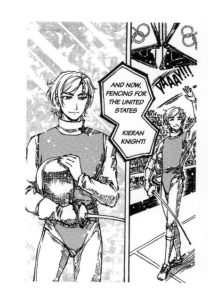

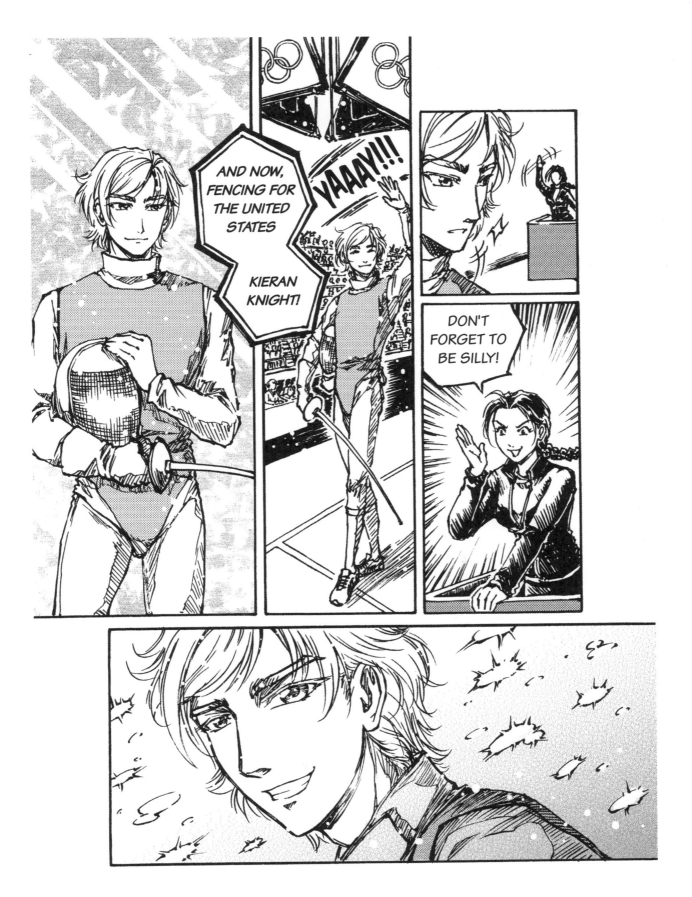

Here is the finished page! Drawing manga takes a lot of work, but the final outcome is well worth the effort.

ABOUT THE AUTHOR

Sonia Leong is a professional comic artist and illustrator specializing in anime and manga. Her first graphic novel was *Manga Shakespeare: Romeo and Juliet* (Harry N. Abrams). Her awards include Young Adult Library Services Association's Quick Picks for Reluctant Young Adult Readers, Best Books for Young Adults 2008, TOKYOPOP's first Rising Stars of Manga competition from 2005 to 2006, and *NEO Magazine*'s 2005 Manga Competition. Sonia contributed to the Eisner Comics Industry Awards-winning *Comic Book Tattoo: Tales Inspired by Tori Amos* (Image Comics). Her work also appears in *Domo: The Manga* (TOKYOPOP) and *Bravest Warriors: The Search for Catbug* (Perfect Square).

Sonia is well known for her work in children's publishing, namely the illustrations for the *I Hero* series (Franklin Watts) by Steve Barlow and Steve Skidmore, *Girls FC* series (Walker) by Helena Pielichaty, and *Ninja* series (Barrington Stoke) by Chris Bradford.

Sonia also works in other fields, such as design, film and television, fashion, and advertising. She is the company secretary for Sweatdrop Studios, a leading comic collaborative and independent publisher of manga based in the United Kingdom. Sonia loves fashion (particularly the Japanese Gothic and Lolita styles), food, and videogames. Learn more at www.fyredrake.net.